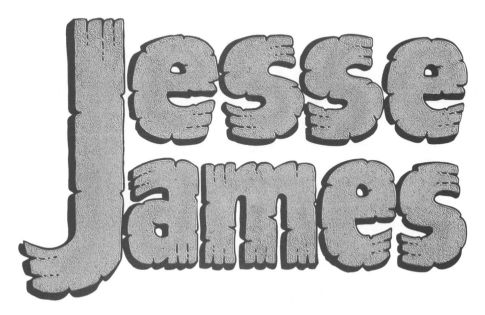

The
Classic Western
Collection

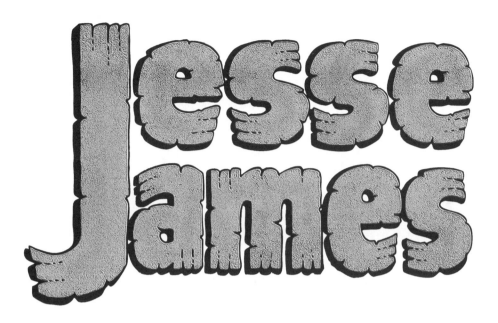

by
Joe Kubert and
Carmine Infantino

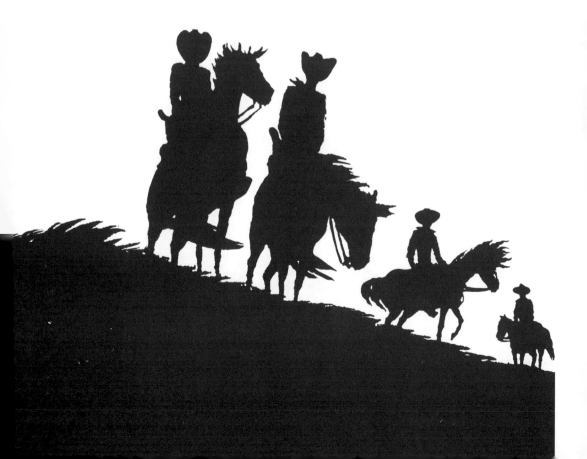

Edited, Compiled, and Designed by J. David Spurlock
Production Assistance: Bob Sharen & Bill Black
Consulting Editor: Roy Thomas

Special Thanks to:
Jim Vadeboncoeur Jr.

Jesse James: The Classic Western Collection is published by
Vanguard Productions 390 Campus Drive, Somerset, NJ 08873.
Collects the stories by Joe Kubert & Carmine Infantino originally published in
Jesse James comics #s 5, 6, & 7 (Avon 1950).
Reproduction strictly prohibited except for review purposes or by permission of the publisher.

Jesse James modified art © Vanguard Productions 2003P
unless otherwise noted.
Editorial contributions, package design and title © 2002 J. David Spurlock.
creativemix.com/vanguard
Hardcover edition ISBN 1-887591-51-6 $27.95
Limited Edition Deluxe Signed and Numbered HC edition ISBN 1-887591-43-5 $39.95
Trade Paperback edition ISBN 1-887591-44-3 $14.95
1st Printing April, 2003
printed in Canada

Table of Contents

YOUNG GUNS...
AN INTRODUCTION

Gunsmoke, Maverick, Bonanza, Have Gun - Will Travel, The Rifleman: the 1950s spawned the greatest Western stories ever! In the Old West the young gunslinger Jesse James rode a hard road to become a legend. In New York City of the early '50s, two young compadres joined forces to prove what they were made of on their way to their own legendary status.

Carmine Infantino circa early 1950s

Joe Kubert is widely considered to be an international master of the comics art form. Renowned for his exceptional artwork on the Golden & Silver Age Hawkman, Tor, Sgt. Rock,

Joe Kubert's critically acclaimed graphic novel, Fax From Sarajevo.

Enemy Ace, *Tales of the Green Beret*, Firehair, *Tarzan*, and many other strips, Joe also runs the lauded Joe Kubert School of Cartoon and Graphic Art. He founded the school in Dover, New Jersey, 25 years ago. Since then he has authored the socially relevant and critically acclaimed graphic novel *Fax from Sarajevo*, as well as the instructional art tome *Super-heroes: Joe Kubert's Wonderful World of Comics*.

Carmine Infantino will always be remembered as the personification of DC Comics' Silver Age. He resurrected a dying comics industry in 1956, with his co-creation, the Flash, and remains the best remembered Flash artist of all time. Infantino proved an all-time great science-fiction artist with his elegant Adam Strange--the only sci-fi comic to rival the sales of *Star Wars*, which Infantino also illustrated. In 1964, he, with editor

Shelly Mayer circa mid-1940s

Julius Schwartz, saved the Batman comics from cancellation with the "New Look," redesigned the Batmobile, and created Batgirl. All of which inspired the *Batman* TV show. In 1971, Infantino became Publisher and later President, of DC Comics. His corporate moves included giving a new generation of talent (Bernie Wrightson, Michael Kaluta, Walt Simonson, Howard Chaykin, and more) their start in comics, as well as innovative formats (*Battle of the Century, Superman Spider-Man* cross-over treasury edition etc.) installing artists Joe Kubert, Joe Orlando, Jack Kirby and Dick Giordano as editors, and development of Superman films I and starring Christopher Reeve.

I first met Joe Kubert around 1997 when I started teaching at the Joe Kubert School of Cartoon and Graphic Art. was only the Kubert School for about year, b happi manage to get few thing accom plished durir that tim Actually, my favorite part teaching there was getting have lunch with Joe, Irw Hasen, Hi Eisman, and oth

Joe Kubert circa early 1950s

OLD FRIENDS

BY J. DAVID SPURLOCK

faculty members.

I met Carmine Infantino shortly after that, through our good mutual friend Joe Orlando. Joe had gotten me hired at the School of Visual Arts in Manhattan and set up a luncheon at the Society of Illustrators for me to meet other SVA faculty. Carmine and I grew very close and have worked on numerous projects together, including Carmine's autobiography, *The Amazing World of Carmine Infantino*, and, with Orlando, produced a lot of Captain Action package art.

Joe Kubert and Carmine Infantino have

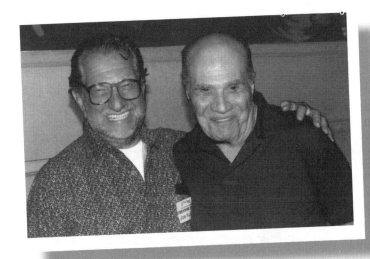

Joe Kubert with Carmine Infantino June 10, 2000

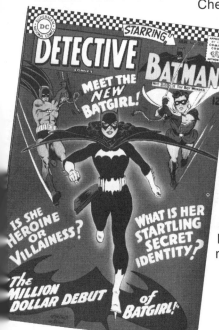

tion shops including Harry Chesler's studio, to being lead-feature artists. Kubert remembers, "Carmine and I met when we started at All-American Comics back in the [mid] 1940s. Shelly Mayer was our editor. Carmine was penciling The Flash and Frank Giacoia was inking his pencils." Max Gaines' All-American Comics was a sibling company that was soon absorbed into DC/National, with Gaines moving on to form

EC Comics.

Shelly Mayer proved to be a great mentor to a new generation of artists that were coming in, including Infantino, Kubert, Alex Toth, Frank Giacoia, and Joe Giella. Irwin Hasen was one of the Golden Age pros already there who became a good friend to these "Young Guns." Hasen said, "Kubert, Infantino, and Toth are the cream of the crop of these young lions." These tyros were young, talented, energetic, and eager to prove themselves to the world. Their work

worked in the comic book field for over sixty years. Both started while still in school: Joe, since the age of 11, and Carmine, when he was about 13, in the late '30s. The two developing artists had similar back-grounds, working their way up from menial chores with various early comics-produc-

Above: Julius Schwartz and Carmine Infantino's Million Dollar Debut of Batgirl.

Right: Infantino & Kubert land the cover of the New York Times Magazine (1971).

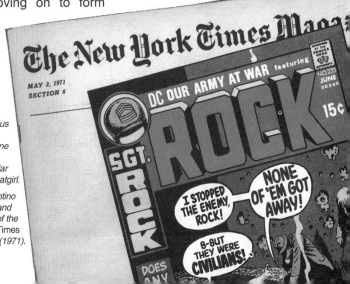

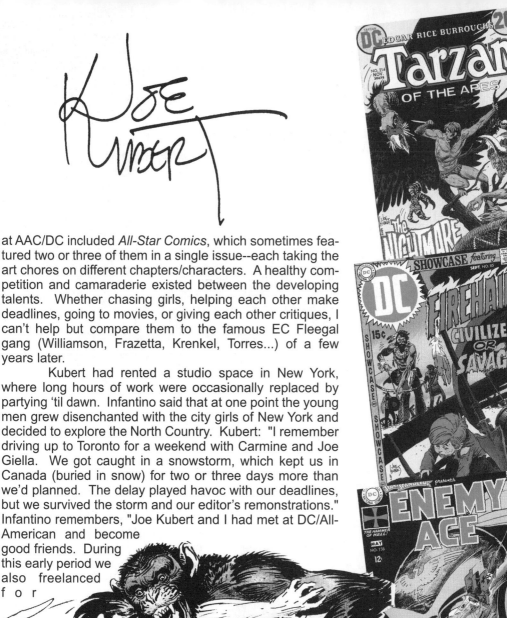

at AAC/DC included *All-Star Comics*, which sometimes featured two or three of them in a single issue--each taking the art chores on different chapters/characters. A healthy competition and camaraderie existed between the developing talents. Whether chasing girls, helping each other make deadlines, going to movies, or giving each other critiques, I can't help but compare them to the famous EC Fleegal gang (Williamson, Frazetta, Krenkel, Torres...) of a few years later.

Kubert had rented a studio space in New York, where long hours of work were occasionally replaced by partying 'til dawn. Infantino said that at one point the young men grew disenchanted with the city girls of New York and decided to explore the North Country. Kubert: "I remember driving up to Toronto for a weekend with Carmine and Joe Giella. We got caught in a snowstorm, which kept us in Canada (buried in snow) for two or three days more than we'd planned. The delay played havoc with our deadlines, but we survived the storm and our editor's remonstrations." Infantino remembers, "Joe Kubert and I had met at DC/All-American and become good friends. During this early period we also freelanced for

Infantino successfully negotiated for DC to obtain the rights to publish Tarzan. He told them, "I've got the best artist in the world for Tarzan--Joe Kubert!"
© ERB Inc.

8

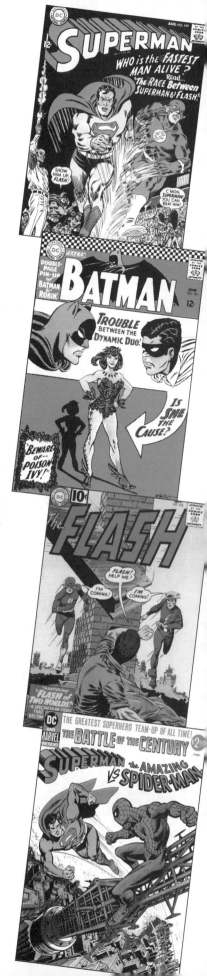

other companies. Joe and I started working together on *Jesse James* for Avon. I penciled one whole *Jesse James* book in one day (or two). I told him, 'Joe, I did this in one day!' He said, 'I'll match you!' And Joe did! Joe inked the whole thing in one day. It was amazing! We did it so fast, we forgot the borders on some of the pages!" It's interesting to note how well this hurried work by two up-and-comers holds up to this day. Also interesting to note is the difference of design and storytelling in the two solo-Kubert stories included (signed "Joe Kubert" and "J.K.," respectively) from the rest of the Infantino-Kubert material.

Though Kubert regularly feels an artist's truest work is not inked by another, he has never hesitated to collaborate with his old friend, Infantino. Kubert: "Carmine's pencils have always made the inker look good. His pencils are complete and detailed. He leaves no doubt about basic construction, anatomy, foreshortening, or perspective. His use of negative space has been a lesson in balance for his contemporaries." After those early days, editor Julius Schwartz teamed Infantino and Kubert for *Showcase* #4, the historic premier of the new Flash, which launched a revival known as the Silver Age of Comics. Kubert says, "Carmine's pencils for The Flash were impressive. His eye for design was remarkable. He used panel variations to

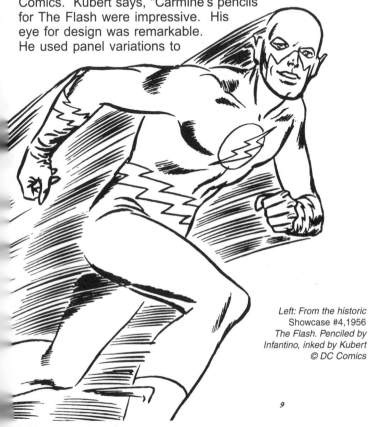

Left: From the historic Showcase #4, 1956 The Flash. Penciled by Infantino, inked by Kubert © DC Comics

increase the momentum and dramatics, never forgetting that clarity of storytelling is paramount to the cartoonist and the reader. Facial expressions and characterization were right on the mark, adding to the story's credibility."

In the '70s, when Carmine was Publisher at DC, he regularly did rough cover designs for the comics. Kubert again: "Carmine and I would discuss the subject matter, after which he would sketch his layout ideas. The guy had an eye. With those sketches as guides, my job became simpler and much more rewarding."

Out of all the fantastic talents Infantino has known, mentored or worked with over the decades, he cites Nick Cardy and Joe Kubert as his favorites.

Jesse James: The Classic Western Collection assembles, for the first time, the 1950's outlaw stories of the often heroic Jesse James, by the (then) young-guns team and (now) comic book legends, Joe Kubert and Carmine Infantino. Included for comparison (mostly in the Deluxe, Signed Hardcover) are works by other notable Jesse James artists Everett Raymond Kinstler (a little more experienced than our young guns) and a very young Wally Wood (who would soon catch up).

– J. David Spurlock April 18, 2003

Pow-Wow Smith
*One of Carmine Infantino's
other Western strips.*
© DC Comics

JESSE JAMES

THE LIBERTY BANK ROBBERY!

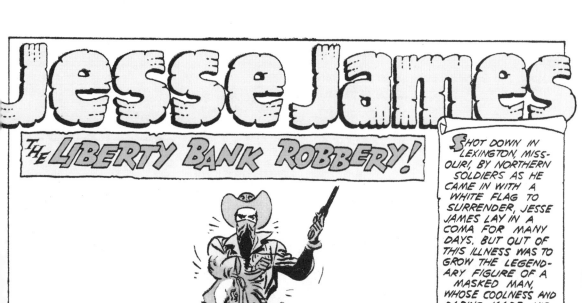

SHOT DOWN IN LEXINGTON, MISSOURI, BY NORTHERN SOLDIERS AS HE CAME IN WITH A WHITE FLAG TO SURRENDER, JESSE JAMES LAY IN A COMA FOR MANY DAYS. BUT OUT OF THIS ILLNESS WAS TO GROW THE LEGENDARY FIGURE OF A MASKED MAN, WHOSE COOLNESS AND DARING MADE HIS NAME A HOUSEHOLD WORD IN THE U.S. FOR JESSE JAMES WAS TO LIVE FROM THOSE AWFUL GUNSHOT WOUNDS! HE WAS TO LIVE TO BECOME A ROBIN HOOD OF THE MIDDLE BORDER, TO BECOME THE FIRST BANK ROBBER IN THE U.S.! IT WAS HIS GENIUS FOR DETAIL AND FOR PLANNING AN ATTACK, THAT MADE HIM FAMOUS IN THE CIVIL WAR, THAT WAS TO COME TO FULL FLOWER IN HIS DARING ROBBERIES, THE FIRST OF WHICH WAS.....

THE LIBERTY BANK ROBBERY

WOUNDED IN THIGH AND CHEST, AND BLEEDING HEAVILY, JESSE WAS CARRIED HALF-DEAD OUT OF LEXINGTON, AS HIS CONFEDERATE GUERRILLAS FOUGHT A REAR-GUARD ACTION...

EASY, JIM! HE'S HURT BAD!

HURT? HE'S DOGGONE NEAR *DEAD!*

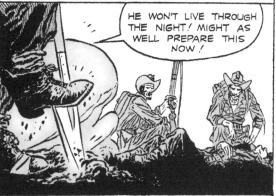

HIS FRIENDS BROUGHT JESSE OUT OF TOWN AND INTO THE WOODLANDS SURROUNDING IT. JESSE LAY LIMP AND LIFELESS, AS ONE OF HIS GUERRILLAS BEGAN TO DIG HIS GRAVE...

HE WON'T LIVE THROUGH THE NIGHT! MIGHT AS WELL PREPARE THIS NOW!

A GROUP OF BLUECOATED UNION SOLDIERS, SEARCHING FOR THE WELL-KNOWN GUERRILLA LEADER, JESSE JAMES, STUMBLED ACROSS THE CONFEDERATE SOLDIERS...

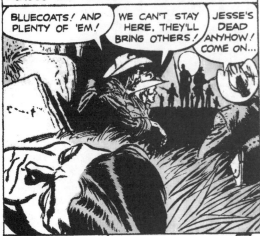

BLUECOATS! AND PLENTY OF 'EM!

WE CAN'T STAY HERE, THEY'LL BRING OTHERS!

JESSE'S DEAD ANYHOW! COME ON...

BUT JESSE WAS NOT DEAD! FEARFULLY WOUNDED IN CHEST AND LEG, HE LAY BABBLING INSANELY THROUGH HALF THE NIGHT...

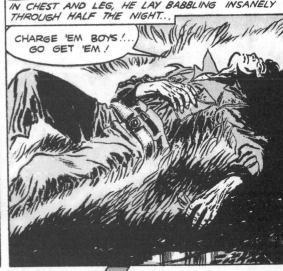

CHARGE 'EM BOYS!... GO GET 'EM!

TOWARD DAWN, JESSE CAME OUT OF HIS DELIRIUM WEAK AND SHAKING. YOUNG AND HARD, WITH A BODY TOUGHENED BY WORK ON A FARM AND HIS YEARS OF GUERRILLA WARFARE, HE WAS STILL ALIVE, THOUGH TORN WITH WOUNDS THAT WOULD HAVE KILLED AN ORDINARY MAN!

GOT TO GIT AWAY! MUST BE A PLACE SOMEWHERE NEAR HERE WHERE THEY WON'T LET A CONFEDERATE SOLDIER DIE LIKE A DOG...

JESSE TOOK THE REST OF THAT NIGHT TO CRAWL A FEW HUNDRED YARDS TO THE DOORSILL OF A WOMAN NAMED BOWMAN...

OHHH! IT'S POOR JESSE! JESSE JAMES!

FOR DAYS, JESSE LAY IN THE BOWMAN FARMHOUSE NEAR DEATH. FINALLY HIS FRIENDS MOVED HIM, IN A HAY WAGON, OUT OF INDEPENDENCE AND NORTH TO NEBRASKA, WITH THE CONSENT OF THE UNION ARMY...

I'LL PASS HIM THROUGH. HE'S SO NEAR DEATH NOW, IT DOESN'T MATTER!

THANK YOU, SIR!

IN RULO, NEBRASKA, WHERE HIS STEPFATHER AND MOTHER HAD MOVED DURING THE WAR, JESSE LAY IN BED, SUFFERING THROUGH FEVER AND DELIRIUM. THE NEW ATMOSPHERE WAS STRANGE, AND JESSE DID NOT LIKE IT...

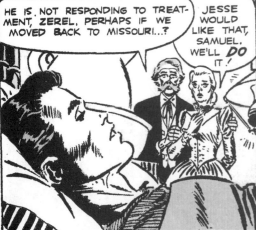

HE IS, NOT RESPONDING TO TREATMENT, ZEREL, PERHAPS IF WE MOVED BACK TO MISSOURI...?

JESSE WOULD LIKE THAT, SAMUEL. WE'LL **DO** IT!

JESSE CAME "HOME" IN AUGUST, 1865. AS HE WAS CARRIED OFF THE MISSOURI PADDLEWHEELER, HE SAW PRETTY ZERELDA MIMMS WATCHING HIM WITH PITY IN HER SOFT BLUE EYES...

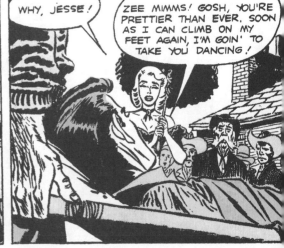

WHY, JESSE!

ZEE MIMMS! GOSH, YOU'RE PRETTIER THAN EVER. SOON AS I CAN CLIMB ON MY FEET AGAIN, I'M GOIN' TO TAKE YOU DANCING!

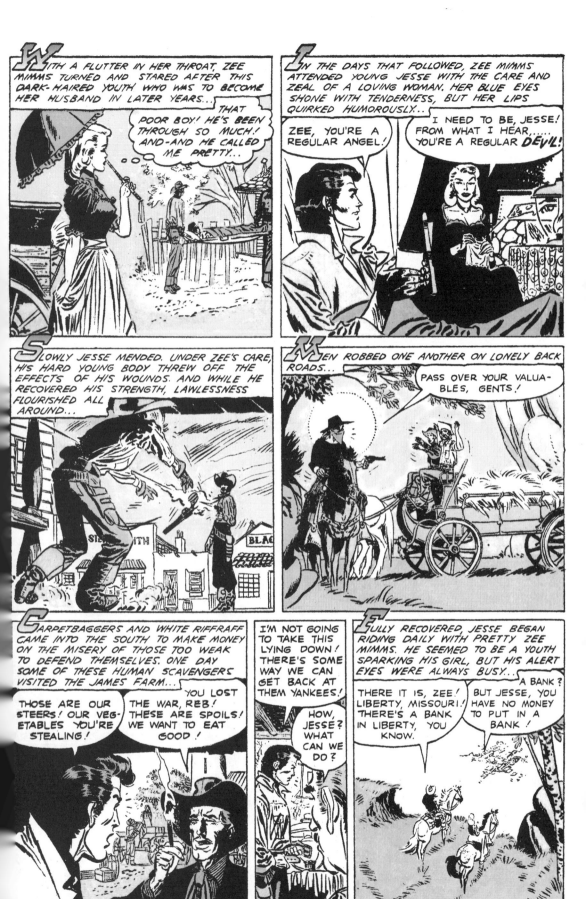

WITH A FLUTTER IN HER THROAT, ZEE MIMMS TURNED AND STARED AFTER THIS DARK-HAIRED YOUTH WHO WAS TO BECOME HER HUSBAND IN LATER YEARS...

THAT POOR BOY! HE'S *BEEN* THROUGH SO MUCH! AND—AND HE CALLED ME *PRETTY*...

IN THE DAYS THAT FOLLOWED, ZEE MIMMS ATTENDED YOUNG JESSE WITH THE CARE AND ZEAL OF A LOVING WOMAN. HER BLUE EYES SHONE WITH TENDERNESS, BUT HER LIPS QUIRKED HUMOROUSLY...

ZEE, YOU'RE A REGULAR ANGEL!

I NEED TO BE, JESSE! FROM WHAT I HEAR,..... YOU'RE A REGULAR *DEVIL!*

SLOWLY JESSE MENDED. UNDER ZEE'S CARE, HIS HARD YOUNG BODY THREW OFF THE EFFECTS OF HIS WOUNDS. AND WHILE HE RECOVERED HIS STRENGTH, LAWLESSNESS FLOURISHED ALL AROUND...

MEN ROBBED ONE ANOTHER ON LONELY BACK ROADS...

PASS OVER YOUR VALUABLES, GENTS!

CARPETBAGGERS AND WHITE RIFFRAFF CAME INTO THE SOUTH TO MAKE MONEY ON THE MISERY OF THOSE TOO WEAK TO DEFEND THEMSELVES. ONE DAY SOME OF THESE HUMAN SCAVENGERS VISITED THE JAMES FARM...

THOSE ARE OUR STEERS! OUR VEGETABLES YOU'RE STEALING!

YOU LOST THE WAR, REB! THESE ARE SPOILS! WE WANT TO EAT GOOD!

I'M NOT GOING TO TAKE THIS LYING DOWN! THERE'S SOME WAY WE CAN GET BACK AT THEM YANKEES!

HOW, JESSE? WHAT CAN WE DO?

FULLY RECOVERED, JESSE BEGAN RIDING DAILY WITH PRETTY ZEE MIMMS. HE SEEMED TO BE A YOUTH SPARKING HIS GIRL, BUT HIS ALERT EYES WERE ALWAYS BUSY...

THERE IT IS, ZEE! LIBERTY, MISSOURI! THERE'S A BANK IN LIBERTY, YOU KNOW.

A BANK? BUT JESSE, YOU HAVE NO MONEY TO PUT IN A BANK!

3

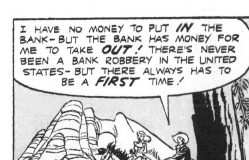

"I HAVE NO MONEY TO PUT *IN* THE BANK—BUT THE BANK HAS MONEY FOR ME TO TAKE *OUT!* THERE'S NEVER BEEN A BANK ROBBERY IN THE UNITED STATES—BUT THERE ALWAYS HAS TO BE A *FIRST* TIME!"

J ESSE JAMES TOLD THE TRUTH! UP UNTIL THIS YEAR, NO BANK IN THE U.S. HAD EVER BEEN ROBBED! TO THE PEOPLE OF 1866, SUCH A FEAT SEEMED AS FANTASTIC AS SOMEONE GOING TO THE MOON. BUT JESSE JAMES HAD GIVEN SUCH A DEED MUCH THOUGHT. HE HAD PERFORMED THE IMPOSSIBLE ON CIVIL WAR BATTLE-FIELDS, AND HE WELCOMED A CHALLENGE SUCH AS THIS WITH COOL CONFIDENCE!

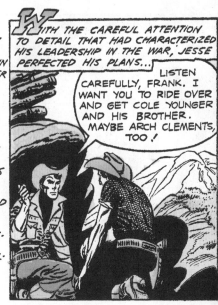

W ITH THE CAREFUL ATTENTION TO DETAIL THAT HAD CHARACTERIZED HIS LEADERSHIP IN THE WAR, JESSE PERFECTED HIS PLANS...

"LISTEN CAREFULLY, FRANK. I WANT YOU TO RIDE OVER AND GET COLE YOUNGER AND HIS BROTHER. MAYBE ARCH CLEMENTS, TOO!"

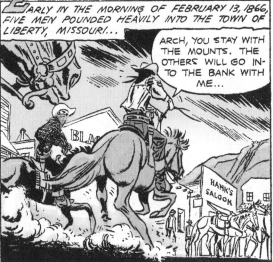

E ARLY IN THE MORNING OF FEBRUARY 13, 1866, FIVE MEN POUNDED HEAVILY INTO THE TOWN OF LIBERTY, MISSOURI!...

"ARCH, YOU STAY WITH THE MOUNTS. THE OTHERS WILL GO IN TO THE BANK WITH ME..."

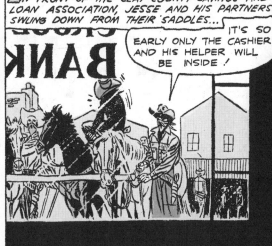

I N FRONT OF THE CLAY COUNTY SAVINGS AND LOAN ASSOCIATION, JESSE AND HIS PARTNERS SWUNG DOWN FROM THEIR SADDLES...

"IT'S SO EARLY ONLY THE CASHIER AND HIS HELPER WILL BE INSIDE!"

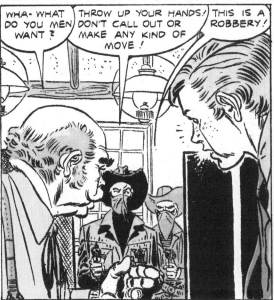

"WHA- WHAT DO YOU MEN WANT?"

"THROW UP YOUR HANDS! DON'T CALL OUT OR MAKE ANY KIND OF MOVE!"

"THIS IS A ROBBERY!"

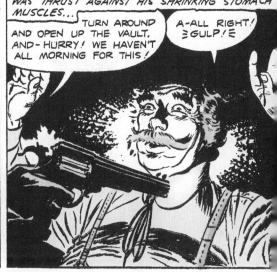

S TUNNED WITH AMAZEMENT, GREENUP BIRD RAISED HIS ARMS HELPLESSLY. A COLT SIXGUN WAS THRUST AGAINST HIS SHRINKING STOMACH MUSCLES...

"TURN AROUND AND OPEN UP THE VAULT. AND—HURRY! WE HAVEN'T ALL MORNING FOR THIS!"

"A-ALL RIGHT! ⋝GULP!⋜"

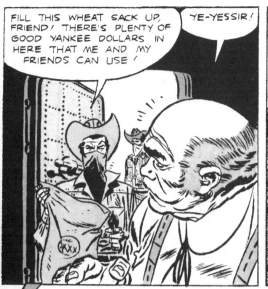

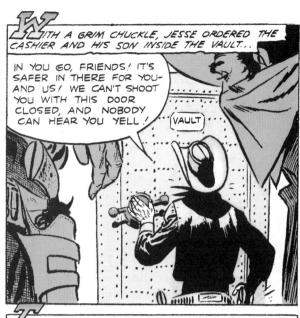

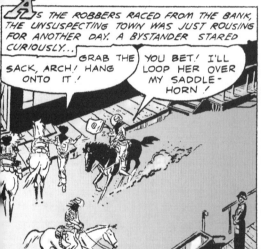

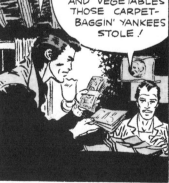

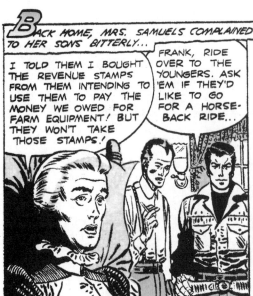

BACK HOME, MRS. SAMUELS COMPLAINED TO HER SONS BITTERLY...

I TOLD THEM I BOUGHT THE REVENUE STAMPS FROM THEM INTENDING TO USE THEM TO PAY THE MONEY WE OWED FOR FARM EQUIPMENT! BUT THEY WON'T TAKE THOSE STAMPS!

FRANK, RIDE OVER TO THE YOUNGERS. ASK 'EM IF THEY'D LIKE TO GO FOR A HORSE-BACK RIDE...

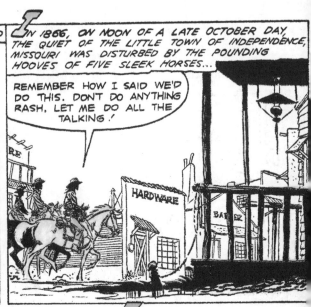

IN 1866, ON NOON OF A LATE OCTOBER DAY, THE QUIET OF THE LITTLE TOWN OF INDEPENDENCE, MISSOURI WAS DISTURBED BY THE POUNDING HOOVES OF FIVE SLEEK HORSES...

REMEMBER HOW I SAID WE'D DO THIS. DON'T DO ANYTHING RASH. LET ME DO ALL THE TALKING!

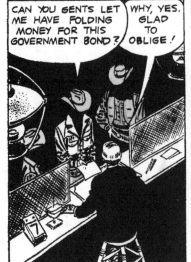

CAN YOU GENTS LET ME HAVE FOLDING MONEY FOR THIS GOVERNMENT BOND?

WHY, YES. GLAD TO OBLIGE!

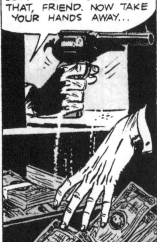

JUST KEEP IT OPEN LIKE THAT, FRIEND. NOW TAKE YOUR HANDS AWAY...

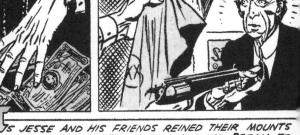

JESSE THREW THE SAME WHEAT SACK HE HAD USED IN LIBERTY AT THE STARTLED CASHIER, WHOSE EYES WIDENED IN DISMAY...

PUT TWO THOUSAND DOLLARS IN THIS SACK, MY FRIEND. TWO THOUSAND DOLLARS!

A WHEAT SACK! THE- THE SAME KIND OF SACK USED IN THE LIBERTY BANK ROBBERY...

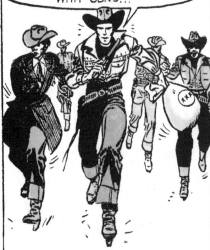

LET'S GET OUT OF HERE, PRONTO! IT ISN'T EARLY MORNING NOW..... THERE'S PLENTY OF MEN AROUND WITH GUNS...

AS JESSE AND HIS FRIENDS REINED THEIR MOUNTS AROUND FOR THEIR GETAWAY GALLOP, GUNS BEGAN TO SOUND. BULLETS FLEW ALL AROUND THE ROBBERS!

IT'S THE LIBERTY BANK ROBBERS!

THEY GOT A SACKFUL OF MONEY FROM THIS BANK, TOO!

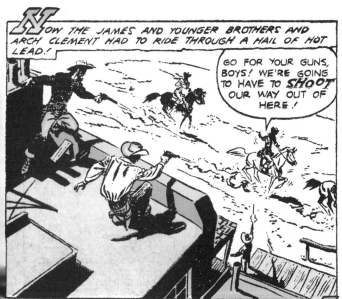

NOW THE JAMES AND YOUNGER BROTHERS AND ARCH CLEMENT HAD TO RIDE THROUGH A HAIL OF HOT LEAD!

GO FOR YOUR GUNS, BOYS! WE'RE GOING TO HAVE TO *SHOOT* OUR WAY OUT OF HERE!

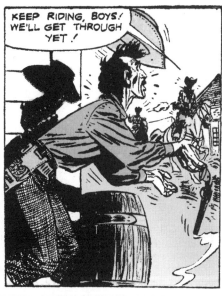

KEEP RIDING, BOYS! WE'LL GET THROUGH YET!

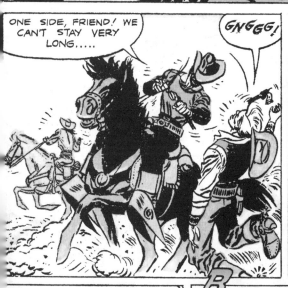

ONE SIDE, FRIEND! WE CAN'T STAY VERY LONG.....

GNGGG!

JESSE'S SIXGUNS SPOKE ONCE, THEN AGAIN... AND AS THE LAST TWO GUNFIGHTERS DROPPED BEFORE HIM, THE WAY WAS CLEAR OUT OF TOWN...

RECKON MOM'S GOING TO MAKE THAT TWO THOUSAND DOLLAR PAYMENT AFTER ALL!

WE'LL SPLIT UP HERE LIKE WE DID AFTER THE LIBERTY ROBBERY. THEY'LL BE LOOKING FOR *FIVE* MEN! BY CUTTING ACROSS THIS ROCKY GROUND, OUR HOOFMARKS WON'T SHOW. THEN WHEN WE SEPARATE, THEY CAN FOLLOW ONLY ONE MAN!

BUT THE POSSE FROM INDEPENDENCE LOST THE TRAIL COMPLETELY...

NO SENSE IN SEARCHING FURTHER.

I GUESS SO. HOOFMARKS DON'T SHOW ON STONE LIKE THIS! THEY GOT AWAY CLEAN!

SOMEWHAT LATER, IN THE JAMES' FARMHOUSE...

HERE YOU ARE, MOM. TWO THOUSAND DOLLARS!

YOU CAN PAY OFF THAT NOTE NOW—TO THE BANK IN INDEPENDENCE!

7

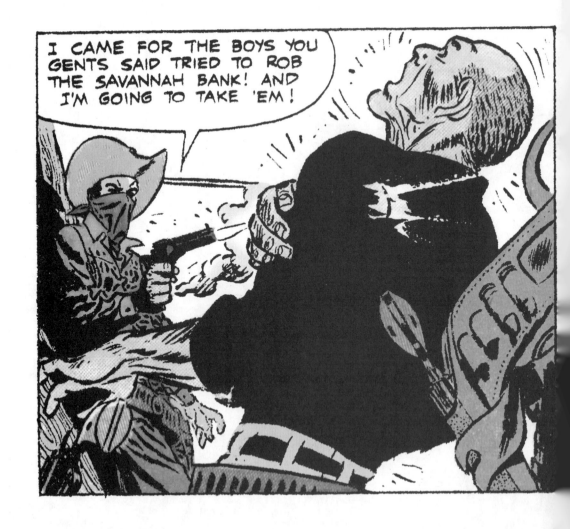

Jesse James

THE DISASTER AT SAVANNAH!

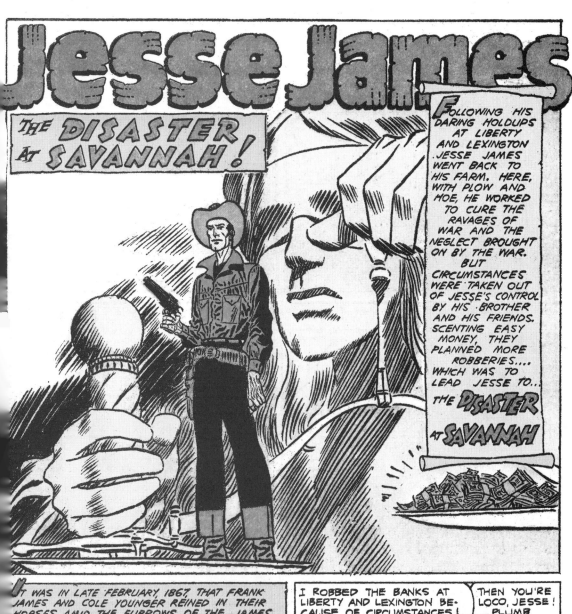

Following his daring holdups at Liberty and Lexington, Jesse James went back to his farm. Here, with plow and hoe, he worked to cure the ravages of war and the neglect brought on by the war. But circumstances were taken out of Jesse's control by his brother and his friends. Scenting easy money, they planned more robberies.... which was to lead Jesse to... THE DISASTER AT SAVANNAH

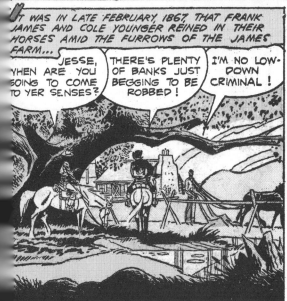

It was in late February, 1867, that Frank James and Cole Younger reined in their horses amid the furrows of the James farm...

JESSE, WHEN ARE YOU GOING TO COME TO YER SENSES?

THERE'S PLENTY OF BANKS JUST BEGGING TO BE ROBBED!

I'M NO LOW-DOWN CRIMINAL!

I ROBBED THE BANKS AT LIBERTY AND LEXINGTON BECAUSE OF CIRCUMSTANCES! I DON'T INTEND TO SET OUT ON A ROAD AGENT'S CAREER!

THEN YOU'RE LOCO, JESSE! PLUMB LOCO!

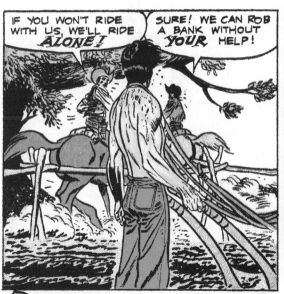

IF YOU WON'T RIDE WITH US, WE'LL RIDE **ALONE!**

SURE! WE CAN ROB A BANK WITHOUT **YOUR** HELP!

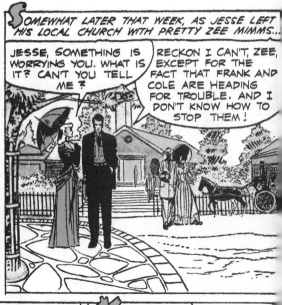

SOMEWHAT LATER THAT WEEK, AS JESSE LEFT HIS LOCAL CHURCH WITH PRETTY ZEE MIMMS...

JESSE, SOMETHING IS WORRYING YOU. WHAT IS IT? CAN'T YOU TELL ME?

RECKON I CAN'T, ZEE, EXCEPT FOR THE FACT THAT FRANK AND COLE ARE HEADING FOR TROUBLE. AND I DON'T KNOW HOW TO STOP THEM!

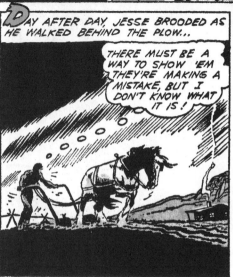

DAY AFTER DAY, JESSE BROODED AS HE WALKED BEHIND THE PLOW...

THERE MUST BE A WAY TO SHOW 'EM THEY'RE MAKING A MISTAKE, BUT I DON'T KNOW WHAT IT IS!

—**O**R OUT RIDING WITH ZEE...

STILL WORRYING?

GUESS I AM. I'M NOT MUCH FUN, AM I? BUT THINGS KEEP BOTHERING ME. I'M AFRAID FRANK'S GOING TO GET INTO A PECK OF TROUBLE!

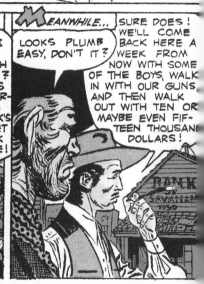

MEANWHILE...

LOOKS PLUMB EASY, DON'T IT?

SURE DOES! WE'LL COME BACK HERE A WEEK FROM NOW WITH SOME OF THE BOYS, WALK IN WITH OUR GUNS, AND THEN WALK OUT WITH TEN OR MAYBE EVEN FIFTEEN THOUSAND DOLLARS!

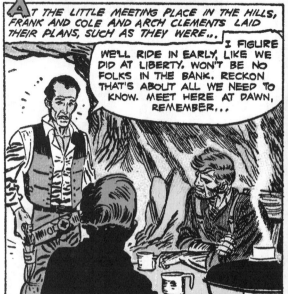

AT THE LITTLE MEETING PLACE IN THE HILLS, FRANK AND COLE AND ARCH CLEMENTS LAID THEIR PLANS, SUCH AS THEY WERE...

I FIGURE WE'LL RIDE IN EARLY, LIKE WE DID AT LIBERTY. WON'T BE NO FOLKS IN THE BANK. RECKON THAT'S ABOUT ALL WE NEED TO KNOW. MEET HERE AT DAWN, REMEMBER...

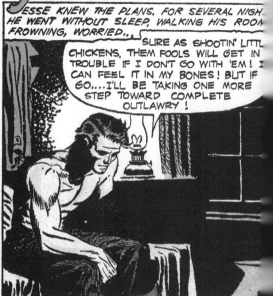

JESSE KNEW THE PLANS. FOR SEVERAL NIGHTS HE WENT WITHOUT SLEEP, WALKING HIS ROOM, FROWNING, WORRIED...

SURE AS SHOOTIN' LITTLE CHICKENS, THEM FOOLS WILL GET IN TROUBLE IF I DON'T GO WITH 'EM! I CAN FEEL IT IN MY BONES! BUT IF I GO....I'LL BE TAKING ONE MORE STEP TOWARD COMPLETE OUTLAWRY!

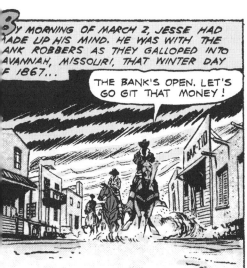

BY MORNING OF MARCH 2, JESSE HAD MADE UP HIS MIND. HE WAS WITH THE BANK ROBBERS AS THEY GALLOPED INTO SAVANNAH, MISSOURI, THAT WINTER DAY OF 1867...

THE BANK'S OPEN. LET'S GO GIT THAT MONEY!

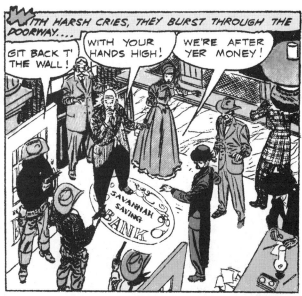

WITH HARSH CRIES, THEY BURST THROUGH THE DOORWAY....

GIT BACK T' THE WALL!

WITH YOUR HANDS HIGH!

WE'RE AFTER YER MONEY!

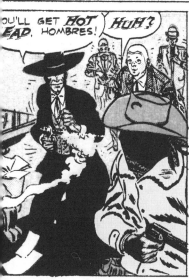

YOU'LL GET HOT LEAD, HOMBRES!

HUH?

I'M BANK GUARD NUMBER TWO, GENTS! I CAN SHOOT, TOO!

OWW!

I'M NUMBER THREE! POUR THE LEAD TO 'EM, BOYS! WE GOT 'EM RIGHT WHERE WE WANT 'EM!

I'LL TRADE BULLETS WITH YOU ANY DAY!

GET TO YOUR HORSES, YOU FOOLS! THESE GUNSHOTS WILL ROUSE UP THE WHOLE TOWN! HAVEN'T YOU ANY BETTER SENSE THAN TO STAND HERE SHOOTING WHEN EVERYBODY'S LIVES ARE IN DANGER?

YOU SEE WHAT A HORNET'S NEST YOU'VE PULLED DOWN ON OUR EARS? WE'LL BE LUCKY IF ANYONE GETS OUT OF THIS ALIVE!

BANG!

BA

IN A HAIL OF BULLETS, JESSE JAMES TOOK THE LEAD AS HE BROUGHT THE BANDITS DOWN SAVANNAH'S DUSTY MAIN STREET AT FULL GALLOP...

THREE BANK GUARDS! AND NOT ONE OF YOU MEN KNEW THEY WERE THERE! BECAUSE OF YOUR STUPIDITY—WE GOT NOTHING! AND WE'RE LIABLE TO LOSE OUR LIVES!

THROUGH THIS ALLEYWAY! PRONTO!

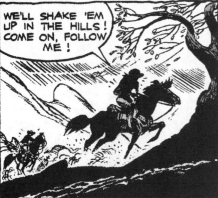

JESSE QUICKLY TOOK COMMAND OF THE DISASTROUS SITUATION. WHILE HE HAD LET COLE YOUNGER PLAN AND CARRY OUT THE BANK ROBBERY ITSELF, IN THE TIME OF EMERGENCY, IT WAS JESSE WHO TOOK OVER...

WE'LL SHAKE 'EM UP IN THE HILLS! COME ON, FOLLOW ME!

AND ONCE SAFELY BEYOND PURSUIT, JESSE LASHED OUT SAVAGELY...

A TRIO OF FOOLS! ANY SENSIBLE PERSON WOULD HAVE LEARNED THAT BANK HAD HIRED GUARDS! NEXT TIME YOU PULL A TRICK LIKE THAT, I MAY NOT BE AROUND TO HAUL YOU OUT!

SOME DAYS LATER, AS JESSE W___ BRINGING A WAGONLOAD OF HAY ___ HIS FARM...

SO MCKINNEY'S LOST HIS MARE, HAS HE? I'LL KEEP IT IN MIND,....

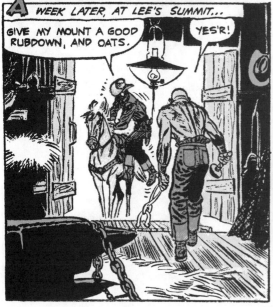

A WEEK LATER, AT LEE'S SUMMIT...

GIVE MY MOUNT A GOOD RUBDOWN, AND OATS.

YES'R!

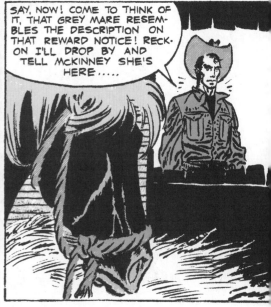

SAY, NOW! COME TO THINK OF IT, THAT GREY MARE RESEMBLES THE DESCRIPTION ON THAT REWARD NOTICE! RECKON I'LL DROP BY AND TELL MCKINNEY SHE'S HERE.....

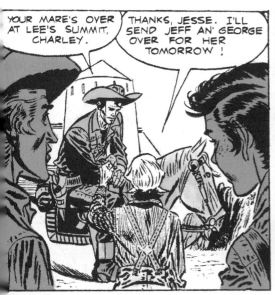

YOUR MARE'S OVER AT LEE'S SUMMIT, CHARLEY.

THANKS, JESSE. I'LL SEND JEFF AN' GEORGE OVER FOR HER TOMORROW!

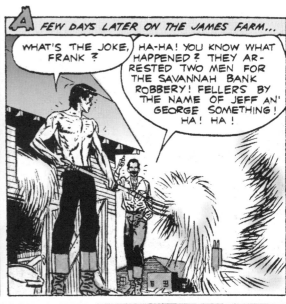

A FEW DAYS LATER ON THE JAMES FARM...

WHAT'S THE JOKE, FRANK?

HA-HA! YOU KNOW WHAT HAPPENED? THEY ARRESTED TWO MEN FOR THE SAVANNAH BANK ROBBERY! FELLERS BY THE NAME OF JEFF AN' GEORGE SOMETHING! HA! HA!

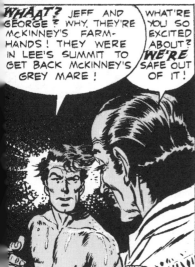

WHAAT? JEFF AND GEORGE? WHY, THEY'RE MCKINNEY'S FARMHANDS! THEY WERE IN LEE'S SUMMIT TO GET BACK MCKINNEY'S GREY MARE!

WHAT'RE YOU SO EXCITED ABOUT? WE'RE SAFE OUT OF IT!

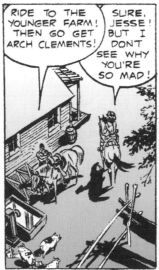

RIDE TO THE YOUNGER FARM! THEN GO GET ARCH CLEMENTS!

SURE, JESSE! BUT I DON'T SEE WHY YOU'RE SO MAD!

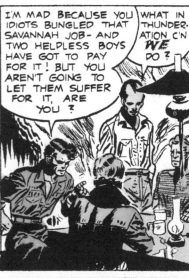

I'M MAD BECAUSE YOU IDIOTS BUNGLED THAT SAVANNAH JOB—AND TWO HELPLESS BOYS HAVE GOT TO PAY FOR IT! BUT YOU AREN'T GOING TO LET THEM SUFFER FOR IT, ARE YOU?

WHAT IN THUNDERATION C'N WE DO?

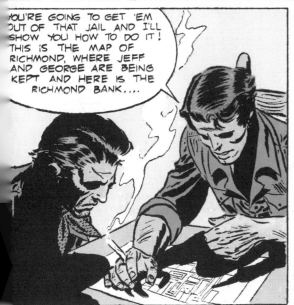

YOU'RE GOING TO GET 'EM OUT OF THAT JAIL AND I'LL SHOW YOU HOW TO DO IT! THIS IS THE MAP OF RICHMOND, WHERE JEFF AND GEORGE ARE BEING KEPT AND HERE IS THE RICHMOND BANK....

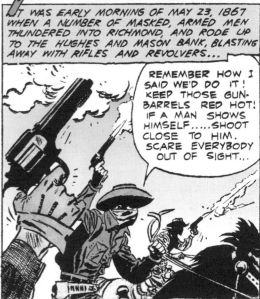

IT WAS EARLY MORNING OF MAY 23, 1867 WHEN A NUMBER OF MASKED, ARMED MEN THUNDERED INTO RICHMOND, AND RODE UP TO THE HUGHES AND MASON BANK, BLASTING AWAY WITH RIFLES AND REVOLVERS...

REMEMBER HOW I SAID WE'D DO IT! KEEP THOSE GUNBARRELS RED HOT! IF A MAN SHOWS HIMSELF.....SHOOT CLOSE TO HIM. SCARE EVERYBODY OUT OF SIGHT...

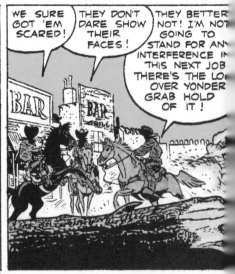

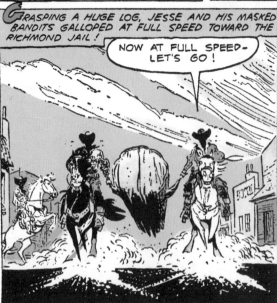

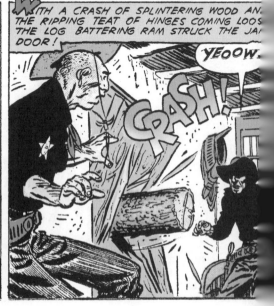

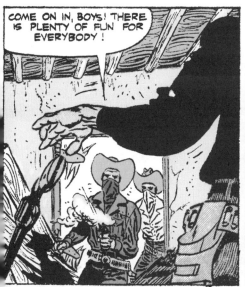

COME ON IN, BOYS! THERE IS PLENTY OF FUN FOR EVERYBODY!

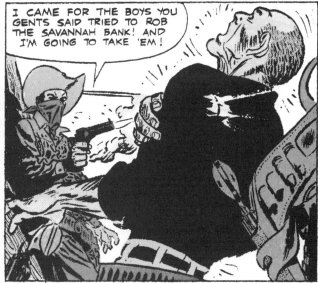

I CAME FOR THE BOYS YOU GENTS SAID TRIED TO ROB THE SAVANNAH BANK! AND I'M GOING TO TAKE 'EM!

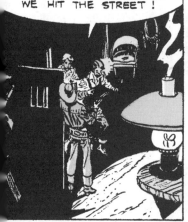

COME ON, JEFF! GEORGE! GET A MOVE ON! WE AIN'T GOT ALL DAY. FOLKS IN THIS TOWN WILL BE UP IN ARMS WHEN WE HIT THE STREET!

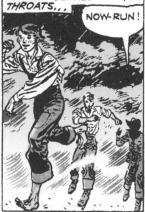

AT A SWIFT CLIP JESSE LED THE TWO FARMHANDS FROM THE JAIL. THE ACRID SMELL OF GUN-POWDER BURNED IN THEIR THROATS...

NOW-RUN!

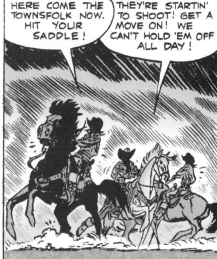

HERE COME THE TOWNSFOLK NOW. HIT YOUR SADDLE!

THEY'RE STARTIN' TO SHOOT! GET A MOVE ON! WE CAN'T HOLD 'EM OFF ALL DAY!

WE'LL HIT FOR THE HILLS AGAIN! THEN WE CAN SCATTER! BUT BEFORE WE DO...

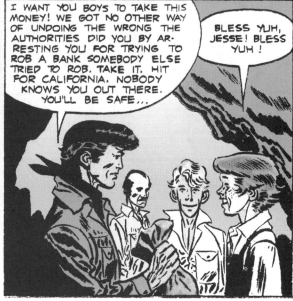

I WANT YOU BOYS TO TAKE THIS MONEY! WE GOT NO OTHER WAY OF UNDOING THE WRONG THE AUTHORITIES DID YOU BY AR-RESTING YOU FOR TRYING TO ROB A BANK SOMEBODY ELSE TRIED TO ROB. TAKE IT. HIT FOR CALIFORNIA. NOBODY KNOWS YOU OUT THERE. YOU'LL BE SAFE...

BLESS YUH, JESSE! BLESS YUH!

JESSE JAMES

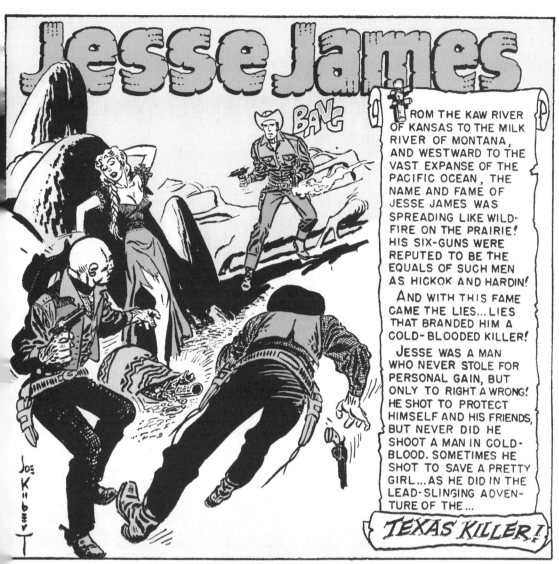

FROM THE KAW RIVER OF KANSAS TO THE MILK RIVER OF MONTANA, AND WESTWARD TO THE VAST EXPANSE OF THE PACIFIC OCEAN, THE NAME AND FAME OF JESSE JAMES WAS SPREADING LIKE WILD-FIRE ON THE PRAIRIE! HIS SIX-GUNS WERE REPUTED TO BE THE EQUALS OF SUCH MEN AS HICKOK AND HARDIN!

AND WITH THIS FAME CAME THE LIES... LIES THAT BRANDED HIM A COLD-BLOODED KILLER!

JESSE WAS A MAN WHO NEVER STOLE FOR PERSONAL GAIN, BUT ONLY TO RIGHT A WRONG! HE SHOT TO PROTECT HIMSELF AND HIS FRIENDS, BUT NEVER DID HE SHOOT A MAN IN COLD-BLOOD. SOMETIMES HE SHOT TO SAVE A PRETTY GIRL... AS HE DID IN THE LEAD-SLINGING ADVEN-TURE OF THE...

TEXAS KILLER!

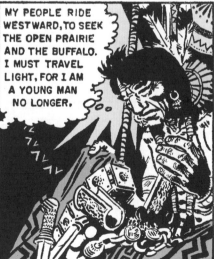

TALL FEATHER WAS A CHOCTAW WAR CHIEF. MANY YEARS AGO HIS PEOPLE HAD FOUND A GOLD MINE, AND HAD FASHIONED EAR-RINGS AND BRACE-LETS FROM THE PRECIOUS METAL. NOW TALL FEATH-ER WAS OLD, AND HIS GOLDEN TRAPPINGS WERE HEAVY....

MY PEOPLE RIDE WESTWARD, TO SEEK THE OPEN PRAIRIE AND THE BUFFALO. I MUST TRAVEL LIGHT, FOR I AM A YOUNG MAN NO LONGER.

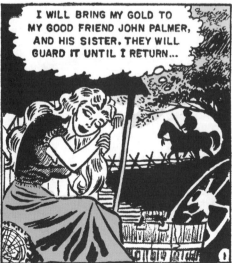

I WILL BRING MY GOLD TO MY GOOD FRIEND JOHN PALMER, AND HIS SISTER. THEY WILL GUARD IT UNTIL I RETURN...

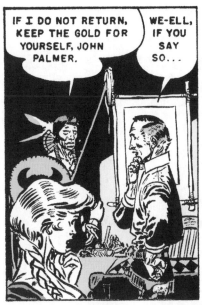

IF I DO NOT RETURN, KEEP THE GOLD FOR YOURSELF, JOHN PALMER.

WE-ELL, IF YOU SAY SO...

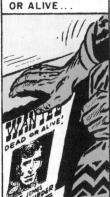

JOHN PALMER OPENED AN OLD TRUNK. FACING HIM WAS A REWARD POSTER READING THAT JESSE JAMES WAS WANTED, DEAD OR ALIVE...

WANTED DEAD OR ALIVE!

AT THAT MOMENT, SOME MILES TO THE NORTH JESSE WAS FLEEING FOR HIS LIFE

WHY DO I GET BLAMED FOR WHAT SOME CHEAP, TWO-BIT CROOK DOES?

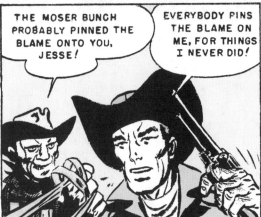

THE MOSER BUNCH PROBABLY PINNED THE BLAME ONTO YOU, JESSE!

EVERYBODY PINS THE BLAME ON ME, FOR THINGS I NEVER DID!

JESSE SHOOK THE POSSE AND HEADED TOWARD A LITTLE CABIN FOR FOOD AND WATER, UNKNOWINGLY RIDING ONTO A DANGER TRAIL...

MAYBE WE CAN GET SOME PROVISIONS FROM THESE FOLKS?

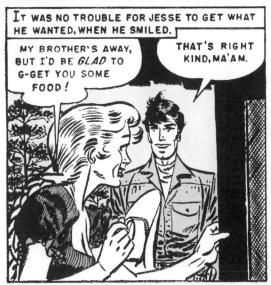

IT WAS NO TROUBLE FOR JESSE TO GET WHAT HE WANTED, WHEN HE SMILED.

MY BROTHER'S AWAY, BUT I'D BE GLAD TO G-GET YOU SOME FOOD!

THAT'S RIGHT KIND, MA'AM.

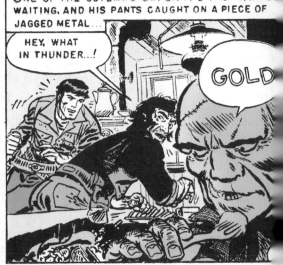

ONE OF THE OUTLAWS SAT ON THE TRUNK, WHILE WAITING, AND HIS PANTS CAUGHT ON A PIECE OF JAGGED METAL...

HEY, WHAT IN THUNDER...!

GOLD

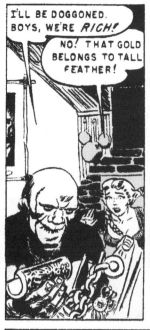

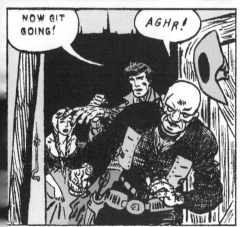

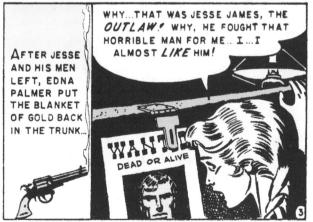

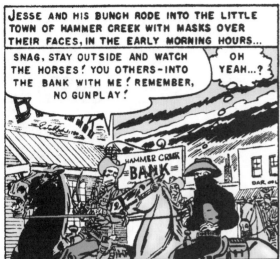

JESSE AND HIS BUNCH RODE INTO THE LITTLE TOWN OF HAMMER CREEK WITH MASKS OVER THEIR FACES, IN THE EARLY MORNING HOURS...

SNAG, STAY OUTSIDE AND WATCH THE HORSES! YOU OTHERS—INTO THE BANK WITH ME! REMEMBER, NO GUNPLAY!

OH YEAH...?

HAMMER CREEK BANK

JESSE HAD PERFECTED A PATTERN OF BANK ROBBERY...

HANDS UP, FOLKS! I'M IN A HURRY, AND I WANT NO TROUBLE!

HIS VOICE WAS HARSH AND CLIPPED...

A POSSE STOLE SOME HORSES OF MINE... SO I'M LETTING YOUR BANK PAY FOR THEM... GET A MOVE ON— PRONTO!

BUT NO SOONER WAS JESSE INSIDE, THAN SNAG BUTLER WHIRLED AND GALLOPED THROUGH TOWN....

BANG

WAHOOO, WAKE UP! JESSE JAMES IS ROBBING YOUR BANK! YAHOOOO!

BAR

AND AS JESSE AND HIS MEN RAN INTO THE STREET, THEY MET A WALL OF RIFLE FIRE...

SNAG RAN OUT ON US!

HE WOKE UP THE WHOLE TOWN!

JESSE— I'M HIT!

HAMMER CREEK BANK 1789

ONCE AGAIN, JESSE JAMES RODE OUT OF TOWN WITH HOT LEAD SINGING ALL ABOUT HIM...

BOYS— ONCE WE'RE PAST TOWN WE'LL SPLIT UP!

FAR AHEAD OF THE FLEEING OUTLAWS—

HEH! HEH! YOU'RE A REGULAR SPITFIRE! I LIKE MY WOMEN SASSY! IT'S MORE FUN TAMING THEM! I'M TAKIN' YOU ALONG TO HELP ME SPEND THAT INJUN'S GOLD!

NO! NO!

4

:SOB: --:SOB:
TH- THEY'LL GET YOU FOR THIS!

GO AHEAD, BABY— CRY IF YUH WANT TO, BUT NOBODY'S GOIN' TO CATCH *ME!* I'M RIDIN' BACK TO TEXAS, AND THEN CROSS THE BORDER INTO MEXICO....

SOME HOURS LATER, AT THE PALMER CABIN...

YOU — JESSE JAMES! MY SISTER SAID YOU WERE A GENTLEMAN— BUT YOU KIDNAPPED HER. AND STOLE TALL FEATHER'S GOLD....

RELAX, PALMER! ONE OF MY MEN DID THAT. BUT I'LL BRING HER BACK!

SHE'D BETTER NOT BE HARMED!

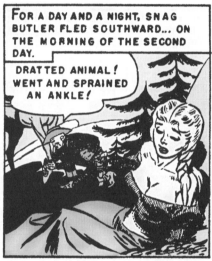

FOR A DAY AND A NIGHT, SNAG BUTLER FLED SOUTHWARD... ON THE MORNING OF THE SECOND DAY.

DRATTED ANIMAL! WENT AND SPRAINED AN ANKLE!

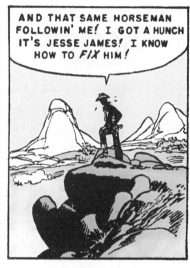

AND THAT SAME HORSEMAN FOLLOWIN' ME! I GOT A HUNCH IT'S JESSE JAMES! I KNOW HOW TO *FIX* HIM!

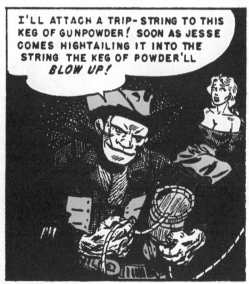

I'LL ATTACH A TRIP-STRING TO THIS KEG OF GUNPOWDER! SOON AS JESSE COMES HIGHTAILING IT INTO THE STRING THE KEG OF POWDER'LL *BLOW UP!*

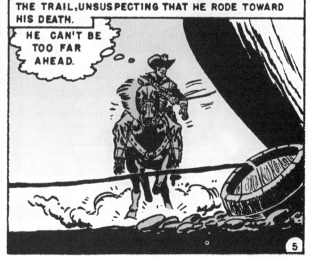

SOMEWHAT LATER, JESSE CAME POUNDING ALONG THE TRAIL, UNSUSPECTING THAT HE RODE TOWARD HIS DEATH.

HE CAN'T BE TOO FAR AHEAD.

5

SUDDENLY A PACK RAT, STARTLED BY THE ONCOMING HOOFS, DARTED FROM THE SHADE OF A THICKET--

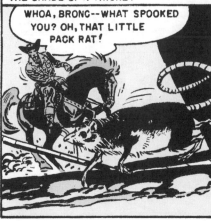

WHOA, BRONC--WHAT SPOOKED YOU? OH, THAT LITTLE PACK RAT!

THE LITTLE BODY HIT THE TRIP STRING, AND--

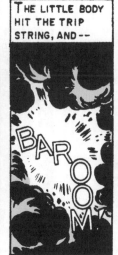

BAROOM

THUNDER AND BLUE BLAZES! WHAT HAPPENED...?

JESSE.. IT WAS THAT SNAG! HE SET A TRAP FOR YOU, KNOCKED ME OUT, AND RODE OFF ON THE ONE GOOD HORSE!

MISS EDNA! DID THAT POLECAT HURT YOU?...

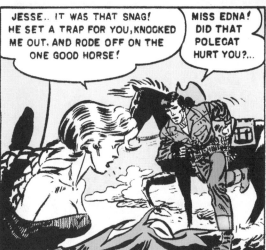

NO... NO, I'M ALL RIGHT, BUT SNAG RODE OFF WITH TALL FEATHER'S GOLD!

HE WON'T RIDE FAR! I'LL GET HIM!

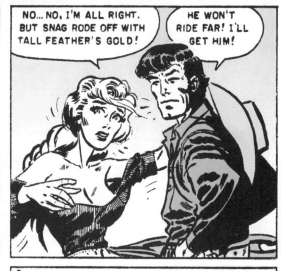

AFTER MAKING SURE THAT EDNA PALMER WAS SAFE, JESSE AGAIN HIT THE TRAIL AFTER SNAG BUTLER...

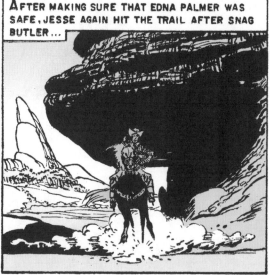

IN A SALOON IN A SMALL COW-TOWN NORTH OF THE RED RIVER, SNAG BUTLER AND JESSE JAMES CAME FACE TO FACE AT LAST...

SNAG BUTLER -- TURN AROUND!

J-J-JESSE J-J-JAMES!

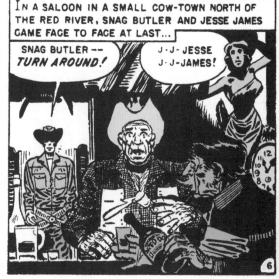

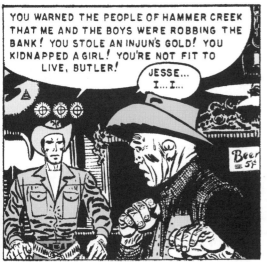

YOU WARNED THE PEOPLE OF HAMMER CREEK THAT ME AND THE BOYS WERE ROBBING THE BANK! YOU STOLE AN INJUN'S GOLD! YOU KIDNAPPED A GIRL! YOU'RE NOT FIT TO LIVE, BUTLER!

JESSE... I... I...

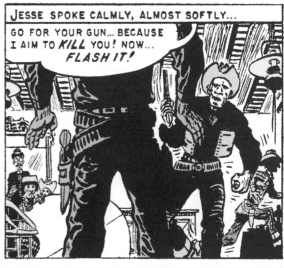

JESSE SPOKE CALMLY, ALMOST SOFTLY...

GO FOR YOUR GUN... BECAUSE I AIM TO *KILL* YOU! NOW... *FLASH IT!*

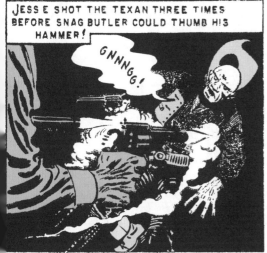

JESSE SHOT THE TEXAN THREE TIMES BEFORE SNAG BUTLER COULD THUMB HIS HAMMER!

GNNNGG!

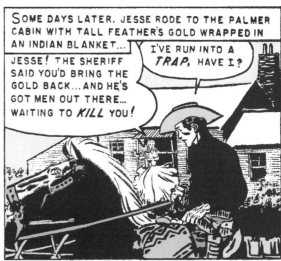

SOME DAYS LATER, JESSE RODE TO THE PALMER CABIN WITH TALL FEATHER'S GOLD WRAPPED IN AN INDIAN BLANKET...

JESSE! THE SHERIFF SAID YOU'D BRING THE GOLD BACK... AND HE'S GOT MEN OUT THERE... WAITING TO *KILL* YOU!

I'VE RUN INTO A *TRAP*, HAVE I?

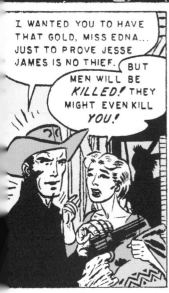

I WANTED YOU TO HAVE THAT GOLD, MISS EDNA... JUST TO PROVE JESSE JAMES IS NO THIEF.

BUT MEN WILL BE *KILLED!* THEY MIGHT EVEN KILL *YOU!*

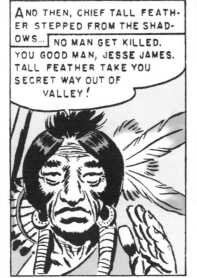

AND THEN, CHIEF TALL FEATHER STEPPED FROM THE SHADOWS...

NO MAN GET KILLED. YOU GOOD MAN, JESSE JAMES. TALL FEATHER TAKE YOU SECRET WAY OUT OF VALLEY!

AND SO, JESSE JAMES RODE ON, OUT OF EDNA PALMER'S LIFE. BUT BEHIND HIM, A GIRL WEPT BITTER TEARS, TO THINK THAT LYING TONGUES WOULD MAKE A MOCKERY OF THIS MAN'S HIGH COURAGE AND GRIM DETERMINATION TO SEE JUSTICE DONE...

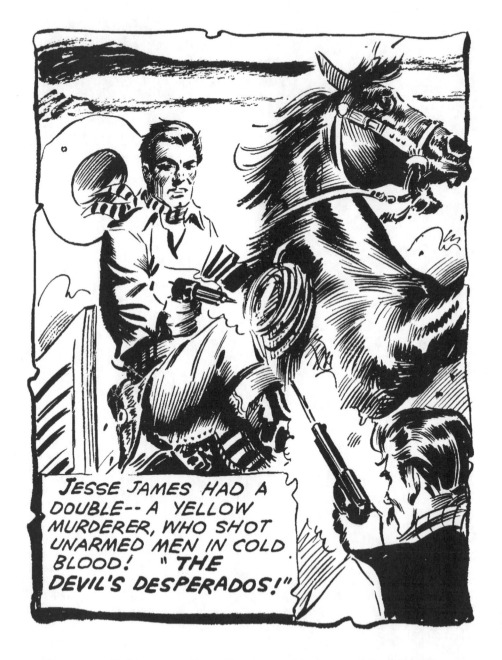

Art on this page by Everett Raymond Kinstler

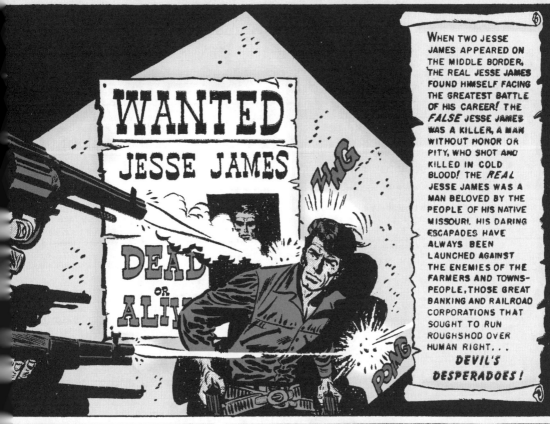

WHEN TWO JESSE JAMES APPEARED ON THE MIDDLE BORDER, THE REAL JESSE JAMES FOUND HIMSELF FACING THE GREATEST BATTLE OF HIS CAREER! THE *FALSE* JESSE JAMES WAS A KILLER, A MAN WITHOUT HONOR OR PITY, WHO SHOT AND KILLED IN COLD BLOOD! THE *REAL* JESSE JAMES WAS A MAN BELOVED BY THE PEOPLE OF HIS NATIVE MISSOURI. HIS DARING ESCAPADES HAVE ALWAYS BEEN LAUNCHED AGAINST THE ENEMIES OF THE FARMERS AND TOWNS-PEOPLE, THOSE GREAT BANKING AND RAILROAD CORPORATIONS THAT SOUGHT TO RUN ROUGHSHOD OVER HUMAN RIGHT...

DEVIL'S DESPERADOES!

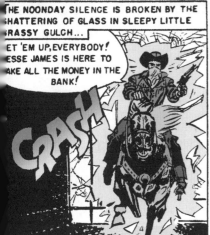

THE NOONDAY SILENCE IS BROKEN BY THE SHATTERING OF GLASS IN SLEEPY LITTLE GRASSY GULCH...

ET 'EM UP, EVERYBODY! ESSE JAMES IS HERE TO AKE ALL THE MONEY IN THE BANK!

CRASH

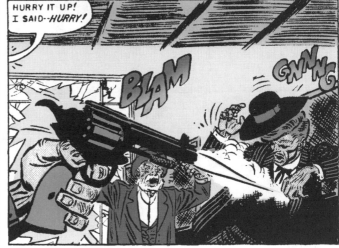

HURRY IT UP! I SAID--*HURRY!*

BLAM

GNNNG

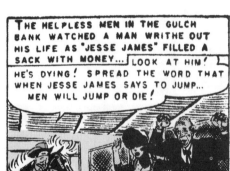

THE HELPLESS MEN IN THE GULCH BANK WATCHED A MAN WRITHE OUT HIS LIFE AS "JESSE JAMES" FILLED A SACK WITH MONEY...

LOOK AT HIM! HE'S DYING! SPREAD THE WORD THAT WHEN JESSE JAMES SAYS TO JUMP... MEN WILL JUMP OR DIE!

THAT WASN'T LIKE JESSE AT ALL!

HE NEVER SHOT ANY-BODY IN COLD BLOOD! WONDER WHAT CAME OVER HIM?

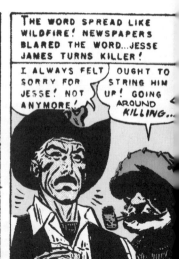

THE WORD SPREAD LIKE WILDFIRE! NEWSPAPERS BLARED THE WORD...JESSE JAMES TURNS KILLER!

I ALWAYS FELT SORRY FOR JESSE! NOT ANYMORE!

OUGHT TO STRING HIM UP! GOING AROUND KILLING...

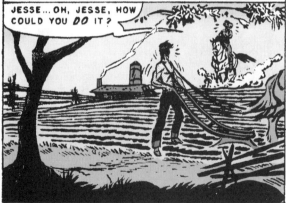

AND ON HIS LITTLE MISSOURI FARM, THE REAL JESSE JAMES PLOWED HIS FIELDS, UNAWARE THAT A TEMPEST WAS RAGING ALL AROUND HIM...

JESSE...OH, JESSE, HOW COULD YOU DO IT?

DO WHAT, ZEE? I DON'T KNOW WHAT YOU'RE TALKING ABOUT!

ROBBED THE GRASSY GULCH BANK THE OTHER DAY... BUT WORSE THAN THAT, YOU SHOT A MAN IN COLD BLOOD! AN UNARMED MAN!

ZEE, I NEVER LEFT THE FARM THE DAY THAT HAPPENED! IF SOMEBODY'S USING MY NAME, I'M NOT TO BLAME FOR IT!

OH, JESSE...FORGIVE ME! I...I DIDN'T MEAN TO LASH OUT AT YOU LIKE THAT! I WAS JUST...SO UPSET...

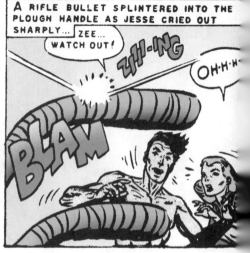

A RIFLE BULLET SPLINTERED INTO THE PLOUGH HANDLE AS JESSE CRIED OUT SHARPLY...

ZEE... WATCH OUT!

ZHI-ING

BLAM

OH-H-H...

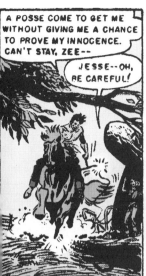

A POSSE COME TO GET ME WITHOUT GIVING ME A CHANCE TO PROVE MY INNOCENCE. CAN'T STAY, ZEE--

JESSE--OH, BE CAREFUL!

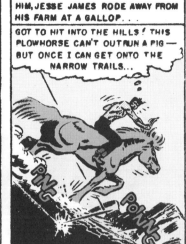

WITH BULLETS FLYING ALL AROUND HIM, JESSE JAMES RODE AWAY FROM HIS FARM AT A GALLOP...

GOT TO HIT INTO THE HILLS! THIS PLOWHORSE CAN'T OUTRUN A PIG -- BUT ONCE I CAN GET ONTO THE NARROW TRAILS...

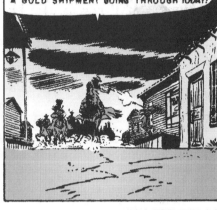

AS THE REAL JESSE FLED FOR HIS LIFE THE IMPOSTER THUNDERED DOWN ON THE TOWN OF CANADAY, GUNS ROARING...

JESSE JAMES IS HERE! BREAK OUT THOSE WELLS-FARGO BOXES! I HEAR TELL, THERE'S A GOLD SHIPMENT GOING THROUGH TODAY!

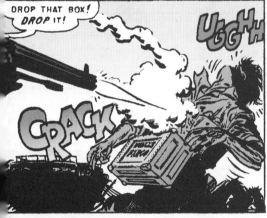

AGAIN THE CRUEL GUNS BLASTED OUT THEIR CURSE OF DEATH...

DROP THAT BOX! DROP IT!

CRACK

UGGH

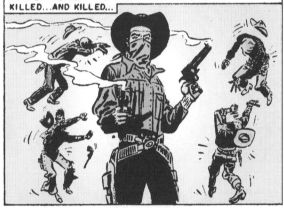

FROM BORDER TO BORDER OF MISSOURI THE WORD WENT OUT--"JESSE JAMES HAS TURNED KILLER! GET HIM-- DEAD OR ALIVE!" AND STILL THE FALSE JESSE JAMES KILLED...AND KILLED...

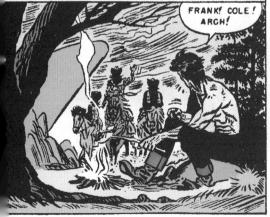

EVEN THEN THE REAL JESSE JAMES WAS HIDING OUT IN THE HILLS, LIVING ON BERRIES AND AN OCCASIONAL RABBIT HE WOULD SHOOT AND COOK. ONE DAY....

FRANK! COLE! ARCH!

WE CAME AS FAST AS WE COULD! HAD TO WAIT BECAUSE FOLKS WERE WATCHING TO SEE IF WE'D LEAD TO YOU! HERE'S A CHANGE OF CLOTHING!

SURE IS GOOD TO SEE YOU. I FEEL LIKE AN ANIMAL, LIVING OUT HERE IN THE WOODS LIKE THIS...

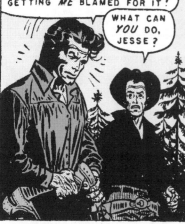

THERE! MY GUNS ON AGAIN! MAYBE THAT MAD KILLER WILL LEARN WHAT IT MEANS TO GO AROUND KILLING PEOPLE... AND GETTING *ME* BLAMED FOR IT!

WHAT CAN *YOU* DO, JESSE?

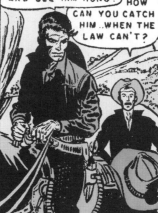

I AIM TO GO OUT AND GET HIM! TO BRING HIM INTO SOME SHERIFF'S OFFICE! THEN I'M RIDING INTO TOWN AND SEE HIM HUNG!

HOW CAN YOU CATCH HIM..WHEN THE LAW CAN'T?

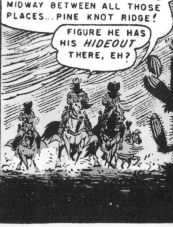

ON JULY 5, HE RAIDED GRASSY GULCH...ON JULY 9, HE HIT CANADAY! TWO DAYS LATER, HAVERSTRAW! ONE POINT IS MIDWAY BETWEEN ALL THOSE PLACES...PINE KNOT RIDGE!

FIGURE HE HAS HIS *HIDEOUT* THERE, EH?

KENO TO THAT! PINE KNOT RIDGE HAS PLENTY OF BIG CAVES IN IT! A BAND OF MEN COULD FURNISH ONE OF THEM PLUMB EASY, AND LIVE THERE FOR YEARS WITHOUT ANYONE KNOWING IT!

JESSE AND FRANK JAMES, COLE AND BOB YOUNGER, AND ARCH CLEMENTS RODE THE PINON RIDGES OF THE PINE KNOT HILLS.

LOOK, COLE! SEE THAT RIDER? HE'S HEADING INTO THE CAVES OVER YONDER! PICK OUT WHICH ONE HE ENTERS AND KEEP AN EYE ON IT! I'LL ROUND UP THE BOYS!

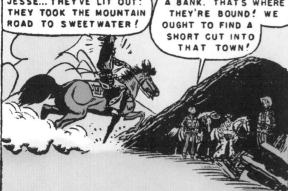

BUT EVEN AS JESSE GATHERED HIS MEN FOR A SHOWDOWN FIGHT, THE FALSE JESSE JAMES GALLOPED OFF WITH HIS GANG...

JESSE...THEY'VE LIT OUT! THEY TOOK THE MOUNTAIN ROAD TO SWEETWATER!

SWEETWATER HAS A BANK. THAT'S WHERE THEY'RE BOUND! WE OUGHT TO FIND A SHORT CUT INTO THAT TOWN!

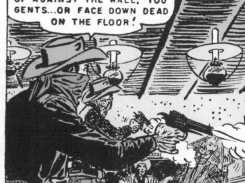

UNAWARE THAT THE REAL JESSE WAS EVEN THEN THUNDERING TOWARD TOWN ON HIS HEELS, THE FALSE OUTLAW GUNNED HIS PATH INTO THE SWEETWATER BANK...

UP AGAINST THE WALL, YOU GENTS...OR FACE DOWN DEAD ON THE FLOOR!

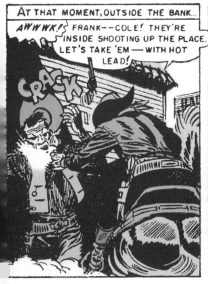

AT THAT MOMENT, OUTSIDE THE BANK...

AWWWK! FRANK--COLE! THEY'RE INSIDE SHOOTING UP THE PLACE. LET'S TAKE 'EM — WITH HOT LEAD!

CRACK

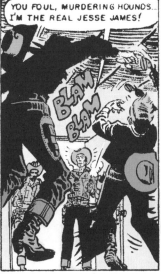

YOU FOUL, MURDERING HOUNDS... I'M THE REAL JESSE JAMES!

BLAM BLAM

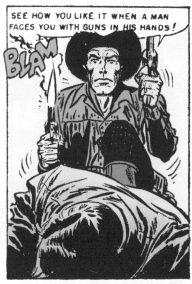

SEE HOW YOU LIKE IT WHEN A MAN FACES YOU WITH GUNS IN HIS HANDS!

BLAM

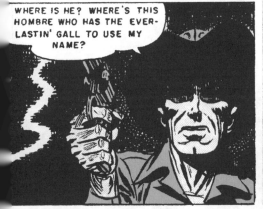

JESSE THROWS LEAD AT THE MEN WHO RUN WITH THE FAKE JESSE JAMES! HIS EYES BLAZE WITH FURY! HIS MOUTH IS A THIN HARD LINE OF RIGHTEOUS HATE.

WHERE IS HE? WHERE'S THIS HOMBRE WHO HAS THE EVER-LASTIN' GALL TO USE MY NAME?

BUT THE FALSE JESSE JAMES WAS NOT WAITING TO INTRODUCE HIMSELF. HIS CHEEKS PASTY-WHITE WITH FEAR, HE DOVE OUT THE REAR DOOR, INTO AN ALLEYWAY...

GOT TO HIGHTAIL IT... THAT REAL JESSE JAMES IS A RING-TAILED WONDER WHEN IT COMES TO USING A PAIR OF COLTS...!

HIS MEN, ALL HARD-BITTEN GUNMEN, DISCOVERED THEIR CHANCE TO RUN WHEN JESSE JAMES SEARCHED THE TOWN FOR HIS NAMESAKE...

HE GOT FIVE OF US— FIVE MEN WITH FIVE SHOTS!

THAT REAL JAMES IS A DEVIL WITH A COLT! —WHEW—

5

RAGING, JESSE STALKED THE LITTLE TOWN WITH SMOKE CURLING FROM HIS GUNS...

YOU PEOPLE! LISTEN! THAT MAD KILLER IS NOT JESSE JAMES! I AM! I'LL BRING HIM IN WITH THE LOOT OF HIS ROBBERIES TO PROVE WHAT I SAY!

AS JESSE RACED OUT OF TOWN, FRANK TURNED TO HIM WITH A BITTER CRY...

WHY'D YOU MAKE SUCH A CRAZY PROMISE? IF YOU DON'T DO JUST THAT, FOLKS'LL THINK YOU'RE IN CAHOOTS WITH HIM!

I SAID I'D DO IT AND I AIM TO! THOSE GALOOTS ARE BLAZING RIGHT NOW FOR THEIR HIDEOUT...SCARED STIFF! THEY'RE READY TO LEAVE THE COUNTRY!

SURE THEY ARE! YOU'LL NEVER CATCH THEM!

THEY WON'T LEAVE WITHOUT THE LOOT OF ALL THEIR ROBBERIES AND KILLINGS, WILL THEY? AND THEY KEEP THAT LOOT IN THEIR HIDEOUT! BUT WE'RE GOING TO GET THERE AHEAD OF 'EM!

AT A MURDEROUS PACE, JESSE FORCED SKY-ROCKET, HIS GREAT COAL-BLACK STALLION THROUGH THE MOUNTAIN TRAILS. HOURS LATER...

WE'RE HERE FIRST! LIGHT DOWN AND FAN OUT. WE'RE GOING INSIDE AND GET THAT LOOT...AND WHEN THAT BLASTED NAME STEALER HITS HERE, HE'LL FIND HOT LEAD!

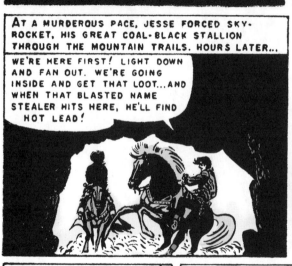

HE SURE DID ALL RIGHT FOR HIMSELF! BANK MONEY! MONEY FROM RAILROAD BAGGAGE CARS! WELLS-FARGO CASH-BOXES TAKEN OFF STAGE COACHES!

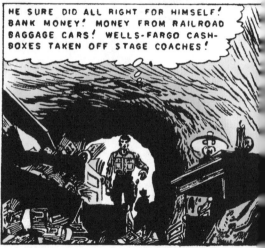

BUT HE'LL PAY FOR EVERY ONE OF THESE JOBS WHERE HE USED MY NAME TO COW PEOPLE, EVEN AS HE GUNNED THEM DOWN! THE DIRTY SIDEWINDER...

JESSE, *HERE THEY COME!*

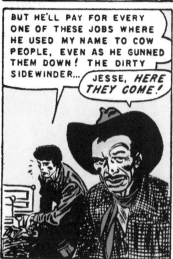

WELCOME TO YOUR CAVE, YOU YELLOW KILLER! LIGHT DOWN AND TASTE THE GREETINGS WE'VE GOT HERE FOR YOU... IN POWDERSMOKE AND LEAD!

IT'S HIM! THE REAL JESSE JAMES!

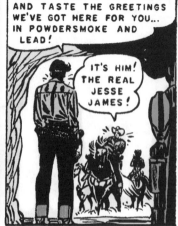

THE THUNDERING CRASH OF HEAVY COLT .45'S SHOOK THE MISSOURI HILLS THAT LONG-GONE AFTERNOON AS REAL AND FALSE MET, WITH DEATH THE JUDGE...

BLAM BLAM

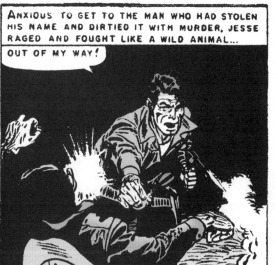

ANXIOUS TO GET TO THE MAN WHO HAD STOLEN HIS NAME AND DIRTIED IT WITH MURDER, JESSE RAGED AND FOUGHT LIKE A WILD ANIMAL...

OUT OF MY WAY!

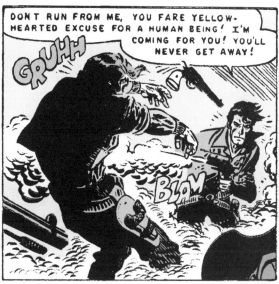

DON'T RUN FROM ME, YOU FARE YELLOW-HEARTED EXCUSE FOR A HUMAN BEING! I'M COMING FOR YOU! YOU'LL NEVER GET AWAY!

GRUHH

BLOM

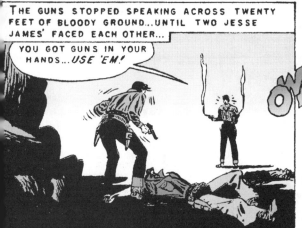

THE GUNS STOPPED SPEAKING ACROSS TWENTY FEET OF BLOODY GROUND...UNTIL TWO JESSE JAMES' FACED EACH OTHER...

YOU GOT GUNS IN YOUR HANDS...USE 'EM!

OW

BANG

DYING BY HOT LEAD IS TOO GOOD FOR YOU, WHOEVER YOU ARE! I WANT TO SEE YOU SWING!

CLICK

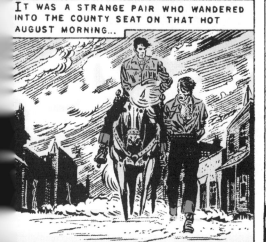

IT WAS A STRANGE PAIR WHO WANDERED INTO THE COUNTY SEAT ON THAT HOT AUGUST MORNING...

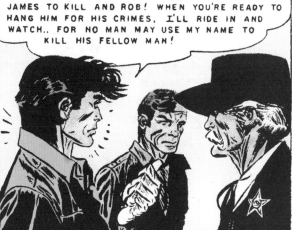

THERE'S THE MAN WHO USED THE NAME OF JESSE JAMES TO KILL AND ROB! WHEN YOU'RE READY TO HANG HIM FOR HIS CRIMES, I'LL RIDE IN AND WATCH.. FOR NO MAN MAY USE MY NAME TO KILL HIS FELLOW MAN!

JESSE JAMES HAD PLUGGED MANY
A LAWMAN BETWEEN THE EYES--AND
NOW HE WORE THE STAR BADGE OF
A SHERIFF! HE TOOK A VACATION FROM
CRIME AND WENT HUNTING... FOR
OUTLAWS! FOR A BRIEF TIME HIS
GUNS SPIT LEAD AND FIRE ON THE
SIDE OF THE LAW!
"JESSE JAMES--SHERIFF!"

Art on this page by Everett Raymond Kinstler

Jesse James

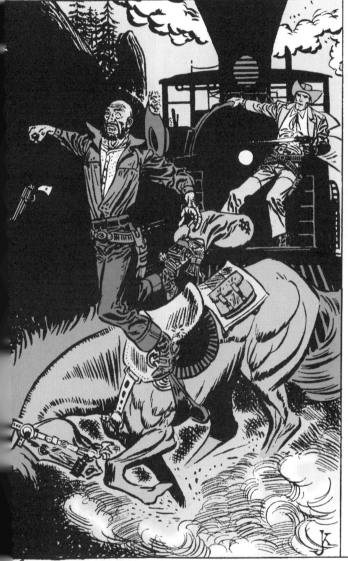

IT WAS TURK MOMSEN AND HIS DOG RIVER BUNCH THAT CAME DOWN ON THE BRANCH TRAIN OF THE UNION PACIFIC JUST OFF THE RIVER FLATS—

THEY'RE **STOPPING**!

HIT FOR THE BAGGAGE CAR—THAT'S WHERE THEY GOT THE **GOLD**!

BLAM

A STRAY BULLET SMASHED A WINDOW NEAR WHICH JESSE JAMES WAS SEATED...

SIZZLIN' SULPHUR! A **HOLDUP**! TRAIN'S CARRYIN' GOLD—THAT'S WHY MOMSEN AND HIS BUNCH ARE AFTER US!—

I'M A PEACEFUL MAN... BUT THERE'S A LIMIT TO WHAT A MAN TAKES ON A TRIP LIKE THIS'.—

ZING

1

O NE OF THE LEAST KNOWN OF ALL THE STRANGE ADVENTURES OF THIS MAN WHO IS KNOWN AS THE GREATEST OUTLAW OF THE UNITED STATES TOOK PLACE IN THE HUMBOLDT RIVER VALLEY IN NEVADA. JESSE WAS CATAPULTED INTO A TRAIN ROBBERY—THIS TIME **AGAINST** THE HOLDUP—WITH THE RESULT THAT JESSE FOUND HIMSELF WITH A STAR BADGE PINNED TO HIS VEST!

THIS BADGE WAS THE MARK OF A FRONTIER SHERIFF—A SYMBOL OF THE LAW AND ORDER THAT JESSE USUALLY FOUGHT **AGAINST** BECAUSE OF THE HATRED AND BIGOTRY OF THE NORTHERN CARPET-BAGGERS AFTER THE CIVIL WAR... BUT WHEN HE FOUND HIMSELF WEARING THAT BADGE, HE DETERMINED TO BE AS GOOD A SHERIFF AS HE WAS AN OUTLAW! HOW WELL HE SUCCEEDED CAN ONLY BE TOLD IN THE GUN-SLAMMING ADVENTURE OF "**JESSE JAMES—SHERIFF!**"

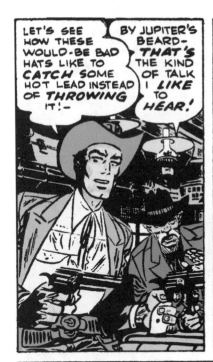

LET'S SEE HOW THESE WOULD-BE BAD HATS LIKE TO *CATCH* SOME HOT LEAD INSTEAD OF *THROWING* IT!—

BY JUPITER'S BEARD— *THAT'S* THE KIND OF TALK I *LIKE* TO *HEAR!*

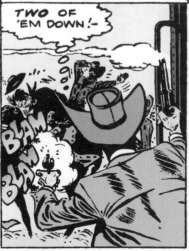

JESSE JAMES WAS A PERFECT FIGHTING MACHINE! GIFTED WITH A KEEN BRAIN AND WONDERFUL EYES, HIS GUNHANDS FAR SURPASSED ANY MAN ON THAT WILD FRONTIER...

TWO OF 'EM DOWN!—

RECKON THERE'S NOTHING LIKE HARD SHOOTING TO DISCOURAGE A MAN FROM STOPPING A TRAIN AND ROBBING IT! ...ONE MORE OF 'EM!—

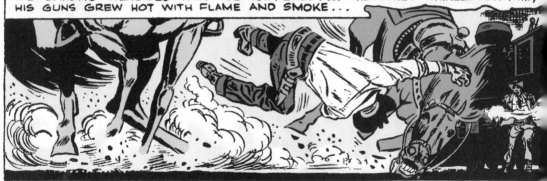

THREE MEN FELL TO JESSE'S BULLETS ON THAT SPRING AFTERNOON BEFORE THE BANDITS REALIZED WHAT HAD HAPPENED! ... WHEN THEY WHIRLED ON HIM, HIS GUNS GREW HOT WITH FLAME AND SMOKE...

FINEST PIECE OF SHOOTIN' I EVER SEEN!—SON, WE *NEED* A GENT LIKE YOU HERE IN NEVADA, WITH THAT TURK MOMSEN AND HIS MEN RUNNING LOOSE!

SOME OF HIS MEN ARE ONLY WOUNDED. WE'D BEST GET THEM TO A HOSPITAL—

TO A HOSPITAL—AND TO A *JAIL!*

THERE'S *BOTH* IN THE NEXT TOWN, WHERE I HAVE MY RANCH—SADDLE GAP! YOUNG MAN, I *INSIST* THAT YOU HAVE LUNCH WITH ME!—WHAT'S YOUR HANDLE?

AMUSEMENT SWAM DEEP IN JESSE JAMES EYES AS HE GAZED INTO THE HONEST FACE OF JOHN SINGER FOR A MOMENT, IT GAVE HIM A LITTLE THRILL TO PLAY THE HERO...

JAMES—ER—MAKE THAT JIMMY! *JIMMY JESSE!*

SOME HOURS LATER, AN IRATE SHERIFF WAS TOSSING HIS BADGE ONTO HIS OFFICE DESK...

SO THIS ONE-MAN ARMY KILLED THREE AND WOUNDED TWO OF TURK MOMSEN'S GANG! *HUH*—RECKON *HE* COULD DO A BETTER JOB AS SHERIFF THAN *ME*! I'M *QUITTIN'*!—

FAIR ENOUGH, ED. I'LL OFFER HIM THE JOB!

TOWARD DUSK, JOHN SINGER MADE HIS REQUEST. WITH A TERRIFIC EFFORT OF WILL POWER, JESSE KEPT FROM LAUGHING...

YOU'LL MAKE A GOOD SHERIFF, JIMMY! MEBBE YOU DON'T KNOW MUCH ABOUT *OUTLAWS*—BUT YOU SURE CAN *SHOOT* STRAIGHT!

IF HE ONLY KNEW HE'S TALKING TO A MAN WANTED IN THREE STATES!—

THIS WAS TOO GOOD A JOKE TO PASS UP!... JESSE REACHED FOR THE BADGE AND PINNED IT ON...

THAT'S RIGHT KIND OF YOU, JOHN! I'LL BE *GLAD* TO BE SHERIFF. THAT MOMSEN IS JUST A BUNGLING FOOL! WHY, EVEN *I* COULD TEACH HIM PLENTY ABOUT BEING AN OUTLAW...

HAW, HAW! *TEACH* HIM—THAT'S A GOOD ONE—HA, HA, HA!

EARLY THE NEXT MORNING, JESSE BROUGHT AN OLD STAGECOACH TO THE LOCAL BLACKSMITH...

I HAVE TO TAKE A MONTH'S GOLD SUPPLY THAT CAME IN ON THAT TRAIN TO THE BANK IN ELKO. CAN YOU FIX THIS STAGE THE WAY I WANT IT?

SURE CAN, SHERIFF—

SOME HOURS LATER, JESSE JAMES LOOKED AT WHAT WAS HIS FIRST INVENTION—THE FATHER OF THE MODERN *ARMORED CAR*!

YESSIR—THAT'S JUST *FINE*! AN IRON-PLATED STAGECOACH! *NOW* LET MOMSEN AND HIS BUNCH TRY TO TAKE THAT GOLD AWAY FROM ME!—

IN THE HIGH HILLS ABOVE THE HUMBOLDT RIVER...

HERE IT COMES!—WE MISSED THAT GOLD WHEN THAT LEAD-THROWIN' STRANGER STOPPED US COLD AT THE TRAIN—BUT *WE'LL GET THAT GOLD NOW!*—

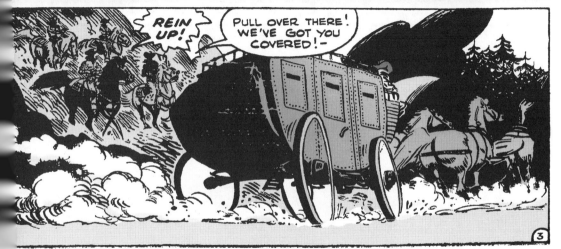

REIN UP!

PULL OVER THERE! WE'VE GOT YOU COVERED!—

3

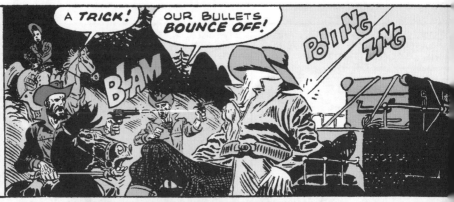

WITH HOWLS OF RAGE, THE WILD BUNCH SAW THE IRON-PLATED COACH! THE DRIVER WAS A STRAW DUMMY!—AND FROM INSIDE THE ARMORED STAGE, RIFLES AND SIXGUNS BELCHED RED DEATH!...

A TRICK!

OUR BULLETS BOUNCE OFF!

PO I NG ZING

BLAM

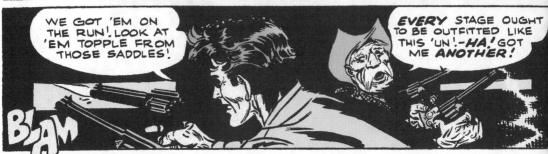

WE GOT 'EM ON THE RUN! LOOK AT 'EM TOPPLE FROM THOSE SADDLES!

EVERY STAGE OUGHT TO BE OUTFITTED LIKE THIS 'UN!—HA! GOT ME ANOTHER!

BLAM

OUTLAW AFTER OUTLAW WENT DOWN BEFORE THAT RELENTLESS HAIL OF DEADLY LEAD... BEFORE TURK MOMSEN COULD THINK OF SHOOTING THE STAGE'S HORSES, THEY WERE PAST HIM AND GALLOPING AWAY...

AND SO, THE NEW SHERIFF OF SADDLE GAP CAME INTO THE HOME STATION OF THE STAGECOACH LINE WITH THE GOLD INTACT...

NEATEST TRICK I EVER DID SEE! HA, HA!—THE FACES O' THEM OUTLAWS WHEN THEY SAW THE STAGE... HA, HA, HA-

BEST DOGGONE SHERIFF WE EVER HAD, BY GUM!

IF THEY ONLY KNEW WHO I REALLY AM!-

WELLS FARGO

JESSE TOOK PRIDE IN HIS NEW JOB... IT AMUSED HIM TO THINK THAT HE COULD MAKE GOOD AS A LAWMAN--

JIMMY, I'M WORRIED... THIS CASH SHIPMENT FOR STEERS IS GOING EAST BY TRAIN- MOMSEN'S LIABLE TO TRY ANOTHER HOLD-UP!...

I KNOW HE WILL! BECAUSE I WANT HIM TO!-

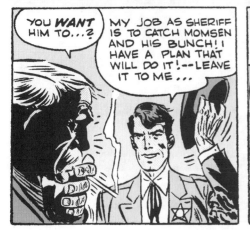

YOU WANT HIM TO...?

MY JOB AS SHERIFF IS TO CATCH MOMSEN AND HIS BUNCH! I HAVE A PLAN THAT WILL DO IT!--LEAVE IT TO ME ...

SOME NIGHTS LATER, JESSE JAMES RODE TOWARD TURK MOMSEN'S CAMPFIRES ... WHEN HE REVEALED HIS IDENTITY, HE WAS WARMLY GREETED...

JESSE JAMES? GOOD T'HAVE YA!- LIGHT DOWN, MAN-- HAVE SOME PORK 'N' BEANS!...

I NEED MONEY MORE THAN I DO FOOD, TURK! IF YOU'LL LISTEN TO ME, I'LL SHOW YOU HOW WE BOTH CAN GET PLENTY!--

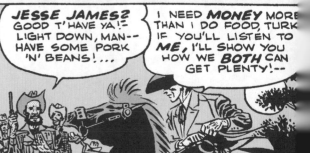

THE OUTLAWS DID NOT RECOGNIZE JESSE AS THE MAN WHO HAD SMASHED THEIR TRAIN ROBBERY ATTEMPT... HE COUNTED ON THE FACT THAT HIS FACE HAD BEEN HIDDEN BY GUNSMOKE --

A BAGGAGE CAR FULL OF *CASH!* - CASH THAT WILL LEAVE NO TRACE! *HALF A MILLION DOLLARS!*

AND IT'S GOING BY UNION PACIFIC, YOU SAY? HMMM -- THAT'S JUST OUR MEAT! --

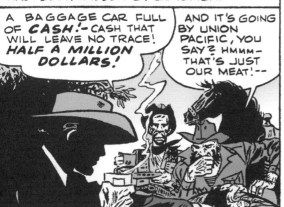

I'LL BE ON THE TRAIN -- IF ANYBODY TAKES A NOTION TO STOP YOU, I'LL GUN HIM DOWN!

I WOULDN'T PUT MUCH FAITH IN YOUR STORY, JESSE - BUT I RECOGNIZED YOU FROM REWARD DODGERS! ME AN' TH' BOYS'LL BE THERE! --

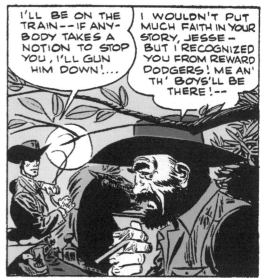

NEXT DAY, AS THE DIAMOND STACK ENGINE PUFFED AROUND ELBOW POINT, A DOZEN GUNS BLASTED...

PULL UP, BLAST YA! -

THIS IS A *HOLDUP!* BRAKE THAT ENGINE - OR *SWALLOW LEAD!*

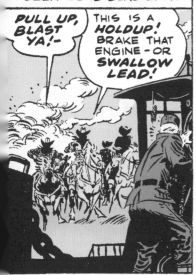

FROM HIDDEN SPOTS IN CARS AND ENGINE, A SOLID WALL OF BULLETS MET THE BANDITS...

THE SHERIFF SURE HAD THE RIGHT IDEA, HIDING US HERE ON THE TRAIN!

WE'LL GIT EVERY ONE O' THAT MOMSEN GANG! --

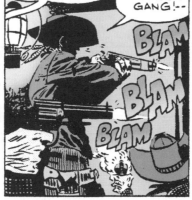

BLAM
BLAM
BLAM

SURRENDER, MOMSEN! EVERY MAN O' YOUR GANG IS DEAD'R WOUNDED!

OKAY - OKAY -- I GIVE UP!!! RECKON JESSE JAMES 'N' ME SURE WALKED INTO A TRAP! ...

JESSE JAMES? HERE? - IN NEVADA? THAT FACE ON THE REWARD DODGER - THAT'S OUR SHERIFF!

YOUR ¿GULP? S-SHERIFF? THEN *HE* PLANNED THIS! *HE* STOPPED TWO OF MY ROBBERIES... TALKED ME INTO THIS... GOT ME ARRESTED... MY MEN SHOT DOWN...

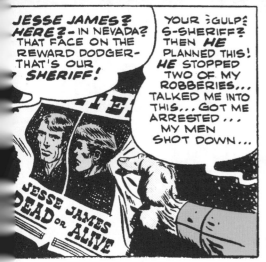

JESSE JAMES
DEAD OR ALIVE

AT THAT MOMENT, MILES AWAY...

GUESS IT'S TIME FOR ME TO QUIT BEIN' A LAWMAN. OH, WELL -- IT WAS FUN, AND *IT PAID WELL* -- ESPECIALLY WHEN I TALKED THE BAGGAGE CAR MAN INTO LETTING *ME* TAKE CARE OF THE CASH -- MY -ER- *FEE,* FOR CATCHING MOMSEN!

The End

5

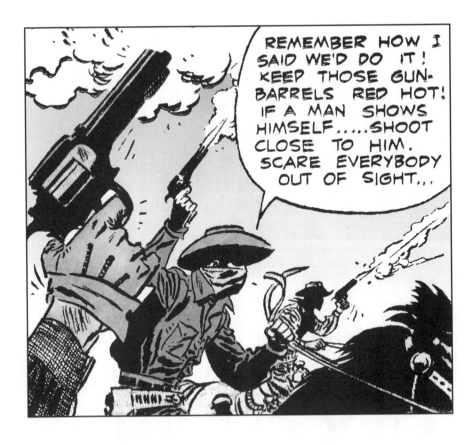

JESSE JAMES

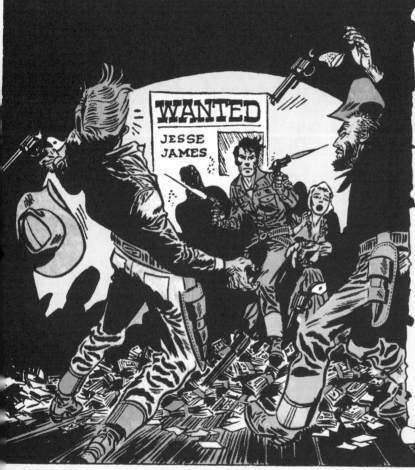

BANK AND TRAIN ROBBER, GUNMAN AND GENTLEMAN, JESSE JAMES RODE THE MISSOURI-KANSAS BORDER IN THE LATTER YEARS OF THE NINETEENTH CENTURY. HIS TWIN SIXGUNS WERE NOT AFRAID TO TALK IN BEHALF OF JUSTICE AND FAIR PLAY! WHEN HIS TRAIL CROSSED THAT OF HIRAM SKINNER, MISER AND HARD HEARTED BUSINESS MAN--WHO WAS NOT ASHAMED TO STEAL FROM A WIDOW--JESSE SHOWED THE CHIVALRY THAT OFTEN RULED HIS ACTIONS! WITH SMOKING SIXGUNS AND GALLOPING HOOVES HE DARED FATE AND DEATH TO BRING JUSTICE TO A HELPLESS WOMAN!

HELLTOWN HOLDUPS!

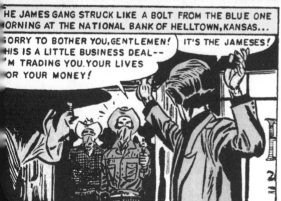

THE JAMES GANG STRUCK LIKE A BOLT FROM THE BLUE ONE MORNING AT THE NATIONAL BANK OF HELLTOWN, KANSAS...

SORRY TO BOTHER YOU, GENTLEMEN! THIS IS A LITTLE BUSINESS DEAL-- I'M TRADING YOU, YOUR LIVES FOR YOUR MONEY!

IT'S THE JAMESES!

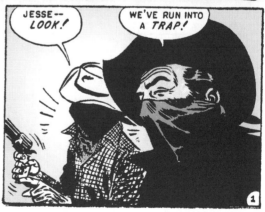

JESSE-- LOOK!

WE'VE RUN INTO A TRAP!

1

THROUGH THE REAR DOORS OF THE BANK CAME ARMED MEN, THEIR GUNS BLAZING...

WE GOT 'EM AT LAST!

RIGHT IN FRONT OF OUR GUNS!

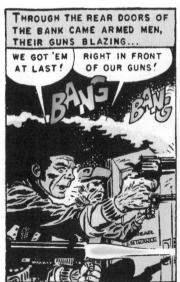

BANG

BANG

KEEP 'EM BUSY, BOYS! I'M NOT LEAVING EMPTY-HANDED!

THEY'RE POURING LEAD PLENTY FAST, JESSE! LET'S GET OUT OF HERE!

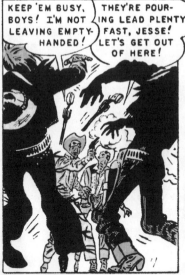

MAKE TRACKS, THEN! I'M NOT GETTING OUT OF HERE UNTIL I GET WHAT I CAME FOR!

GNNGG!

NO TIME TO GET OUT THE DOOR! THEY'D CUT ME IN HALF! ONLY ONE WAY OUT, AND I'VE GOT TO RISK A CUT THROAT TO TAKE IT!

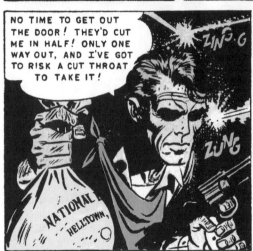

ZING-G

ZUNG

NATIONAL BANK HELLTOWN

THERE WAS THE CRASH AND CLATTER OF SHATTERING GLASS AS JESSE DOVE THROUGH THE SIDE WINDOW OF THE BANK! BULLETS CLIPPED THE WOOD AND GLASS, BUT NONE TOUCHED HIM!

MADE IT! NOW TO MEET THE BOYS AND BURN DAYLIGHT OUT OF HERE! THE WHOLE TOWN WILL BE UP IN ARMS TO GUN US DOWN!

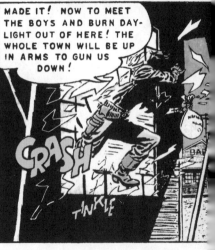

CRASH

TINKLE

REINS LOOSE TO FREE THEIR GUNHANDS, MEN LIKE FRANK JAMES, COLE AND BOB YOUNGER AND ARCH CLEMENTS RODE STANDING IN THEIR STIRRUPS...

KEEP ON TRAVELLING, BOYS! I'M RIGHT WITH YOU. MAYBE THERE'S A CHANCE OF GETTING OUT OF HERE, AFTER ALL!

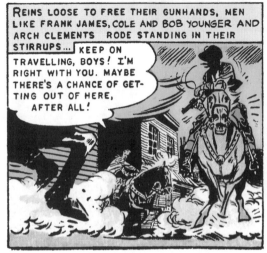

AFTER TWO HOURS OF HARD RIDING, THE JAMES GANG PULLED IN THEIR FOAM-FLECKED BRONCS BEFORE A LITTLE FARM HOUSE THAT WAS STRANGELY QUIET...

THIS PLACE LOOKS DESERTED. DO YOU RECKON WE COULD GET A MEAL, AND SOME WATER FOR OUR HORSES?

NO HARM TRYIN'! KNOCK AT THE DOOR...

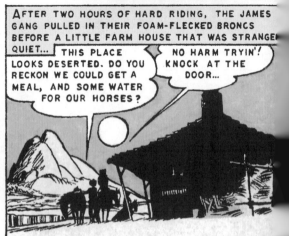

BEFORE JESSE COULD RAP, THE DOOR OPENED...

NO NEED TO KNOCK, STRANGER. COME RIGHT IN. I HAVE A BEEF STEW AND A BERRY PIE IN THE OVEN!

WHY, THAT'S RIGHT KIND, MA'AM!

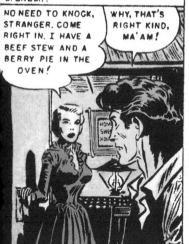

OHH! IT'S HIRAM SKINNER! HE-- HE'LL SEE YOUR HORSES...

SOMEBODY'S COMING! CLEAR OUT THE BACK WAY, WHILE I THANK MIZ BIRDSALL...

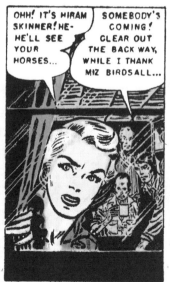

MA'AM, THERE'S TEARS IN YOUR EYES! WHAT'S THIS SKINNER HOMBRE FIXIN' TO DO TO YOU?

HE--HE INTENDS TO FORECLOSE THE MORTGAGE ON MY FARM! I'VE TRIED TO PAY HIM B-BUT HE MAKES ME PAY THIRTY PERCENT, AND AFTER ALL I ONLY OWE ONE THOU-SAND DOLLARS AND--

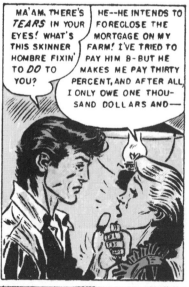

HERE'S A THOUSAND IRON MEN THAT SACK, MA'AM. PAY IT O HIM AND GET A RECEIPT FOR IT!

BUT I CAN'T TAKE YOUR MONEY!

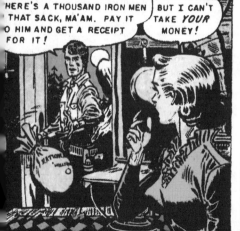

DON'T WORRY ABOUT IT, MA'AM! TASTING YOUR BEEF STEW AND BERRY PIE WAS WORTH EVERY CENT OF IT!

YOU'RE AN ANGEL, MISTER-- WHO-EVER YOU ARE!

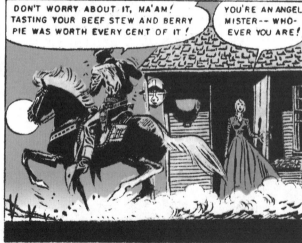

ALF AN HOUR LATER, ON THE HELLTOWN TURNPIKE...

WITH YOUR HANDS, MISTER! IS IS A HOLDUP! WE'LL LIEVE YOU OF THAT MONEY YOU'RE CARRYING!

THIS IS AN OUTRAGE!

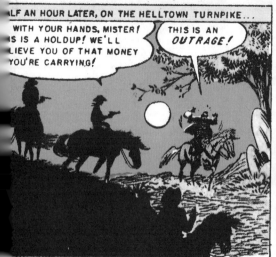

BLASTED CUTTHROATS! STOLE THE MONEY THE WIDOW BIRDSALL GAVE ME! BUT I SHOULD WORRY. IT WON'T COST ME A PENNY!

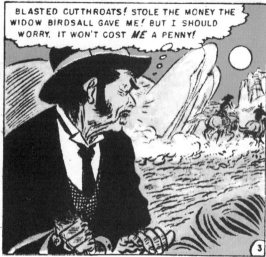

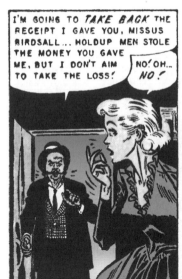

I'M GOING TO *TAKE BACK* THE RECEIPT I GAVE YOU, MISSUS BIRDSALL... HOLDUP MEN STOLE THE MONEY YOU GAVE ME, BUT I DON'T AIM TO TAKE THE LOSS!

NO! OH... *NO!*

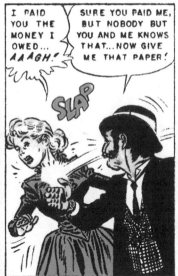

I PAID YOU THE MONEY I OWED... *AAAGH!*

SURE YOU PAID ME, BUT NOBODY BUT YOU AND ME KNOWS THAT... NOW GIVE ME THAT PAPER!

SLAP

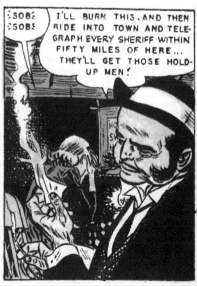

SOB! SOB!

I'LL BURN THIS, AND THEN RIDE INTO TOWN AND TELEGRAPH EVERY SHERIFF WITHIN FIFTY MILES OF HERE... THEY'LL GET THOSE HOLD-UP MEN!

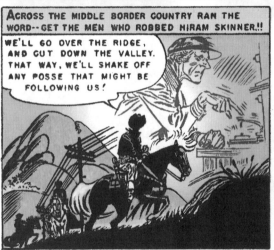

ACROSS THE MIDDLE BORDER COUNTRY RAN THE WORD-- GET THE MEN WHO ROBBED HIRAM SKINNER!!

WE'LL GO OVER THE RIDGE, AND CUT DOWN THE VALLEY. THAT WAY, WE'LL SHAKE OFF ANY POSSE THAT MIGHT BE FOLLOWING US!

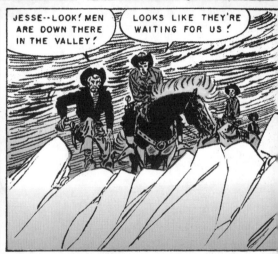

JESSE-- LOOK! MEN ARE DOWN THERE IN THE VALLEY!

LOOKS LIKE THEY'RE WAITING FOR US!

WE'LL HAVE TO GO BACK THE WAY WE CAME!

IF WE GO BACK, WE'LL RIDE INTO THE HELLTOWN SHERIFF AND HIS POSSE!

HIDDEN RIFLES BLAST AS JESSE AND HIS MEN RETRACE THEIR TRACKS!

LOOKS LIKE WE RAN INTO THAT POSSE, ALL RIGHT!

FEED 'EM HOT LEAD AND RUN LIKE BLUE BLAZES!

BLAM

BLAM

BLAM

WE'LL MAKE IT. THEY LEFT THEIR BRONCS SOME DISTANCE AWAY. KEEP RUNNING!

AT FULL GALLOP, JESSE BROUGHT HIS MEN THROUGH THE RAIN OF HOT LEAD...NOT A MAN WAS LOST!

AS MOONLIGHT FLOODED THE MIDDLE BORDER FLAT-LANDS...

OHH! SOMEONE AT THE WINDOW!

DON'T BE ALARMED, MA'AM!

IT'S YOU! THE MAN WHO GAVE ME THAT MONEY.

RECKON I GOT TO THINKIN' ABOUT THAT CHOW I GOT HERE, AND I JUST HAD TO COME BACK FOR MORE.

WHY, YOUR EYES ARE RED! YOU'VE BEEN CRYING! DON'T TELL ME YOU HAD ANY TROUBLE WITH THAT SKINNER HOMBRE?

HE...HE CAME BACK AND...TORE UP THE RECEIPT! HE...HE SAID SOMEBODY STOLE THE MONEY FROM HIM! ;SOB;

THE LOWDOWN POLECAT! YOU BOYS STAY HERE! I GOT ME A JOB TO DO!

BE CAREFUL...

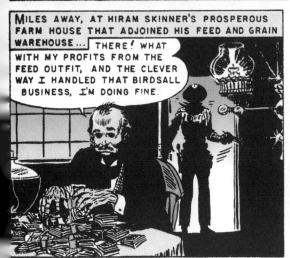

MILES AWAY, AT HIRAM SKINNER'S PROSPEROUS FARM HOUSE THAT ADJOINED HIS FEED AND GRAIN WAREHOUSE...

THERE! WHAT WITH MY PROFITS FROM THE FEED OUTFIT, AND THE CLEVER WAY I HANDLED THAT BIRDSALL BUSINESS, I'M DOING FINE.

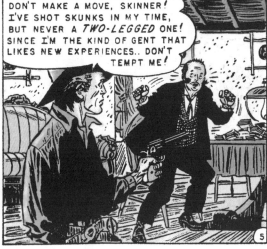

DON'T MAKE A MOVE, SKINNER! I'VE SHOT SKUNKS IN MY TIME, BUT NEVER A TWO-LEGGED ONE! SINCE I'M THE KIND OF GENT THAT LIKES NEW EXPERIENCES.. DON'T TEMPT ME!

5

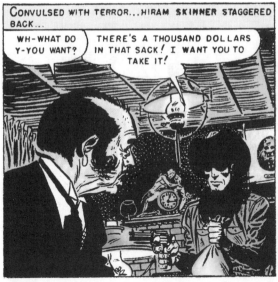

CONVULSED WITH TERROR...HIRAM SKINNER STAGGERED BACK...

WH-WHAT DO Y-YOU WANT?

THERE'S A THOUSAND DOLLARS IN THAT SACK! I WANT YOU TO TAKE IT!

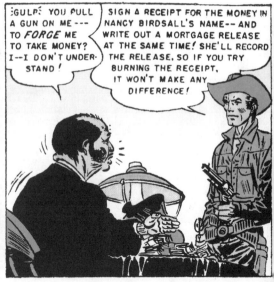

GULP! YOU PULL A GUN ON ME--- TO FORCE ME TO TAKE MONEY? I--I DON'T UNDER-STAND!

SIGN A RECEIPT FOR THE MONEY IN NANCY BIRDSALL'S NAME-- AND WRITE OUT A MORTGAGE RELEASE AT THE SAME TIME! SHE'LL RECORD THE RELEASE, SO IF YOU TRY BURNING THE RECEIPT, IT WON'T MAKE ANY DIFFERENCE!

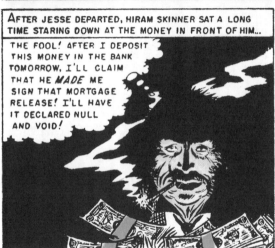

AFTER JESSE DEPARTED, HIRAM SKINNER SAT A LONG TIME STARING DOWN AT THE MONEY IN FRONT OF HIM...

THE FOOL! AFTER I DEPOSIT THIS MONEY IN THE BANK TOMORROW, I'LL CLAIM THAT HE MADE ME SIGN THAT MORTGAGE RELEASE! I'LL HAVE IT DECLARED NULL AND VOID!

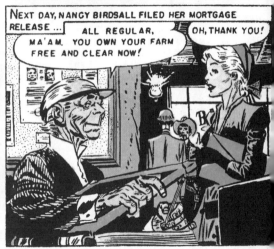

NEXT DAY, NANCY BIRDSALL FILED HER MORTGAGE RELEASE ...

ALL REGULAR, MA'AM. YOU OWN YOUR FARM FREE AND CLEAR NOW!

OH, THANK YOU!

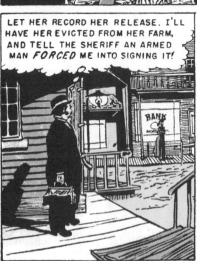

LET HER RECORD HER RELEASE. I'LL HAVE HER EVICTED FROM HER FARM, AND TELL THE SHERIFF AN ARMED MAN FORCED ME INTO SIGNING IT!

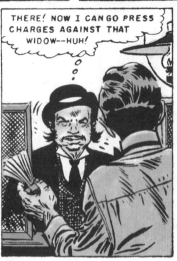

THERE! NOW I CAN GO PRESS CHARGES AGAINST THAT WIDOW--HUH!

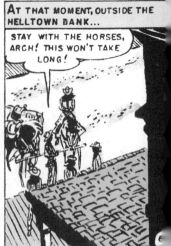

AT THAT MOMENT, OUTSIDE THE HELLTOWN BANK...

STAY WITH THE HORSES, ARCH! THIS WON'T TAKE LONG!

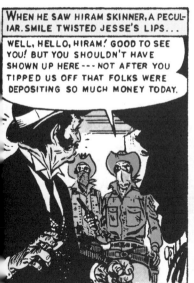

WHEN HE SAW HIRAM SKINNER, A PECULIAR SMILE TWISTED JESSE'S LIPS...

WELL, HELLO, HIRAM! GOOD TO SEE YOU! BUT YOU SHOULDN'T HAVE SHOWN UP HERE --- NOT AFTER YOU TIPPED US OFF THAT FOLKS WERE DEPOSITING SO MUCH MONEY TODAY.

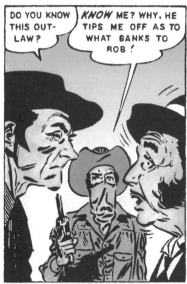

DO YOU KNOW THIS OUTLAW?

KNOW ME? WHY, HE TIPS ME OFF AS TO WHAT BANKS TO ROB!

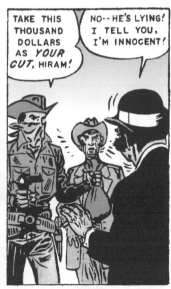

TAKE THIS THOUSAND DOLLARS AS YOUR CUT, HIRAM!

NO-- HE'S LYING! I TELL YOU, I'M INNOCENT!

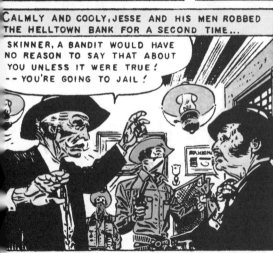

CALMLY AND COOLY, JESSE AND HIS MEN ROBBED THE HELLTOWN BANK FOR A SECOND TIME...

SKINNER, A BANDIT WOULD HAVE NO REASON TO SAY THAT ABOUT YOU UNLESS IT WERE TRUE! -- YOU'RE GOING TO JAIL!

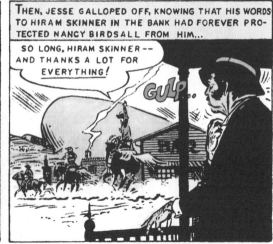

THEN, JESSE GALLOPED OFF, KNOWING THAT HIS WORDS TO HIRAM SKINNER IN THE BANK HAD FOREVER PROTECTED NANCY BIRDSALL FROM HIM...

SO LONG, HIRAM SKINNER -- AND THANKS A LOT FOR EVERYTHING!

GULP...

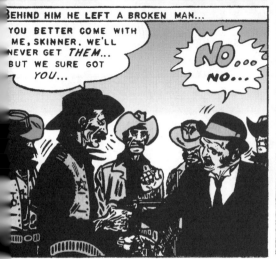

BEHIND HIM HE LEFT A BROKEN MAN...

YOU BETTER COME WITH ME, SKINNER. WE'LL NEVER GET THEM... BUT WE SURE GOT YOU...

NO... NO...

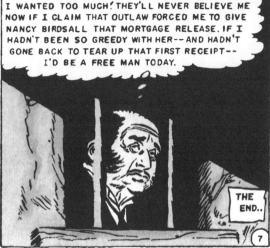

I WANTED TOO MUCH! THEY'LL NEVER BELIEVE ME NOW IF I CLAIM THAT OUTLAW FORCED ME TO GIVE NANCY BIRDSALL THAT MORTGAGE RELEASE. IF I HADN'T BEEN SO GREEDY WITH HER-- AND HADN'T GONE BACK TO TEAR UP THAT FIRST RECEIPT-- I'D BE A FREE MAN TODAY.

THE END..

7

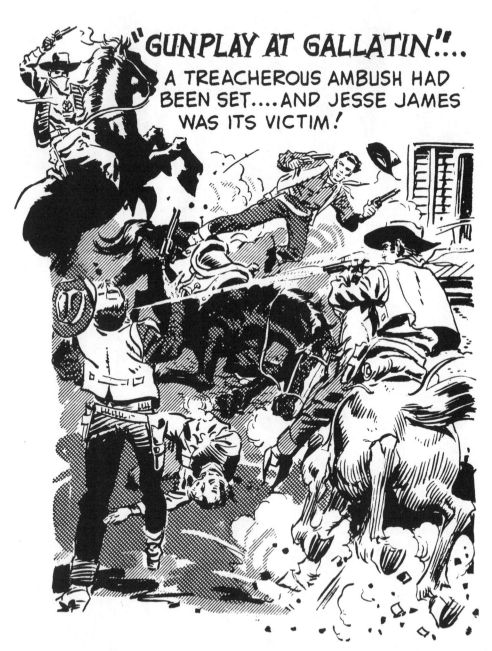

"GUNPLAY AT GALLATIN"!...
A TREACHEROUS AMBUSH HAD BEEN SET....AND JESSE JAMES WAS ITS VICTIM!

Wally Wood

JESSE JAMES

GALLATIN BANK ESTABLISHED 1730

GALLATIN BANK

WHEN JESSE JAMES RETURNED FROM CALIFORNIA IN '68, HE FOUND MUCH OF THE BORDER BITTERNESS OF KANSAS AND MISSOURI--THAT WAS THE RESULT OF THE CIVIL WAR--FADING BEFORE A NEW AND DEADLIER HATRED. FOR, AS THE UNITED STATES EXPANDED WESTWARD, THE RAILROADS AND BANKS CAME WITH IT--AND BETWEEN THESE JUGGERNAUTS OF HIGH FINANCE, THE FARMERS AND MERCHANTS OF THE MIDDLE BORDER WERE CRUSHED.

AND SO, WHEN FIRE DESTROYED A NEIGHBOR'S HOME, JESSE JAMES TOOK DOWN HIS COLTS, AND FOUGHT ONCE AGAIN FOR JUSTICE, EVEN THOUGH THAT FIGHT WAS TO SEE MURDER AND RUTHLESS KILLING IN--

GUNPLAY AT GALLATIN!

THE LATE SUMMER AND EARLY FALL OF 1869 WAS A PEACEFUL PERIOD IN JESSE JAMES' LIFE...

LOOKS LIKE JIM REED'S HAYMOW'S CAUGHT FIRE! RECKON A SPARK FROM A TRAIN'S ENGINE SET IT A-BLAZING!

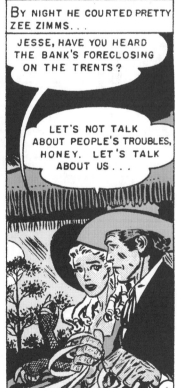

BY NIGHT HE COURTED PRETTY ZEE ZIMMS...

JESSE, HAVE YOU HEARD THE BANK'S FORECLOSING ON THE TRENTS?

LET'S NOT TALK ABOUT PEOPLE'S TROUBLES, HONEY. LET'S TALK ABOUT US...

THOUGH HE TRIED TO IGNORE THEM, EVIDENCE OF HIS NEIGHBORS' TROUBLES WERE EVERYWHERE...EVEN IN CHURCH..

THAT'S THE WIDOW BROWN...HER HUSBAND HUNG HIMSELF WHEN THE BANK TOOK HIS FARM AWAY

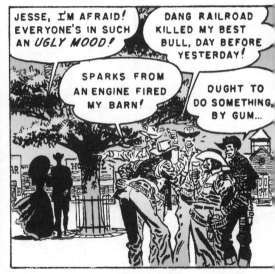

JESSE, I'M AFRAID! EVERYONE'S IN SUCH AN *UGLY MOOD!*

DANG RAILROAD KILLED MY BEST BULL, DAY BEFORE YESTERDAY!

SPARKS FROM AN ENGINE FIRED MY BARN!

OUGHT TO DO SOMETHING, BY GUM...

THE RAILROAD WON'T PAY ENOUGH TO BUY A NEW COW OR BUILD A NEW BARN! AND THAT BANK HAS NO UNDERSTANDING OF A FARMER'S PROBLEMS!

I KNOW, HONEY. BUT... I CAN'T DO ANYTHING...

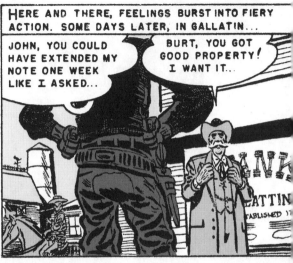

HERE AND THERE, FEELINGS BURST INTO FIERY ACTION. SOME DAYS LATER, IN GALLATIN...

JOHN, YOU COULD HAVE EXTENDED MY NOTE ONE WEEK LIKE I ASKED...

BURT, YOU GOT GOOD PROPERTY! I WANT IT...

BURT TRAVIS LOST HIS TEMPER. HIS HAND WENT DOWN AND CAME UP WITH HIS GUN. BANKER SHAW FLIPPED BACK HIS COAT AND REACHED FOR HIS DERRINGER...

WHY, YOU CROOK! ILL FIX YOU SO...

TALK'S CHEAP, TRAVIS! *SHOOT!*

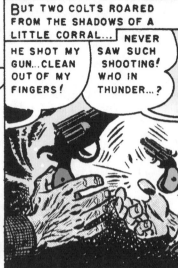

BUT TWO COLTS ROARED FROM THE SHADOWS OF A LITTLE CORRAL...

HE SHOT MY GUN...CLEAN OUT OF MY FINGERS!

NEVER SAW SUCH SHOOTING! WHO IN THUNDER...?

JESSE JAMES!

AREN'T TIMES BAD ENOUGH WITHOUT TRYING TO *KILL* EACH OTHER?

BUT THE ENFORCED PEACE BETWEEN TRAVIS AND BANKER SHAW WAS ONLY TEMPORARY—

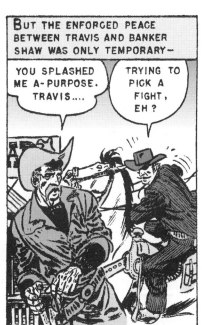

YOU SPLASHED ME A-PURPOSE, TRAVIS....

TRYING TO PICK A FIGHT, EH?

THEY LASHED OUT AT ONE ANOTHER, WITH PENT UP FURY!

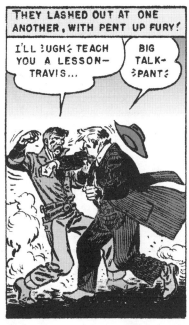

I'LL ?UGH? TEACH YOU A LESSON— TRAVIS...

BIG TALK- ?PANT?

AGAIN IT WAS JESSE WHO INTERCEDED...

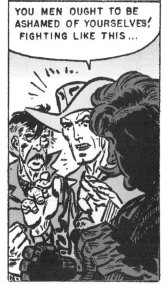

YOU MEN OUGHT TO BE ASHAMED OF YOURSELVES! FIGHTING LIKE THIS...

THAT NIGHT, SPARKS FROM A RAILROAD ENGINE SET FIRE TO THE HOME OF ROSS THURSTON...

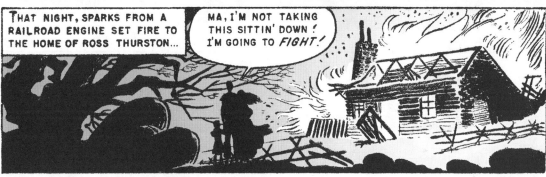

MA, I'M NOT TAKING THIS SITTIN' DOWN! I'M GOING TO FIGHT!

SOME HOURS LATER...

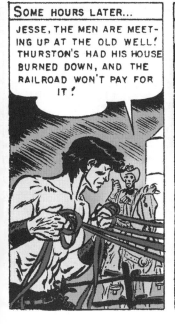

JESSE, THE MEN ARE MEET- ING UP AT THE OLD WELL! THURSTON'S HAD HIS HOUSE BURNED DOWN, AND THE RAILROAD WON'T PAY FOR IT!

LATER...

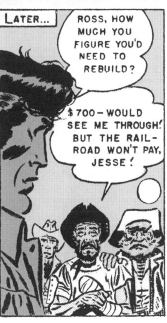

ROSS, HOW MUCH YOU FIGURE YOU'D NEED TO REBUILD?

$700 — WOULD SEE ME THROUGH! BUT THE RAIL- ROAD WON'T PAY, JESSE!

THE NEXT MORNING...

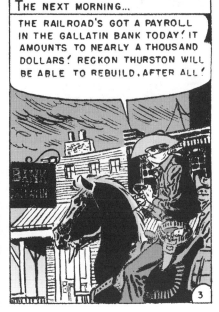

THE RAILROAD'S GOT A PAYROLL IN THE GALLATIN BANK TODAY! IT AMOUNTS TO NEARLY A THOUSAND DOLLARS! RECKON THURSTON WILL BE ABLE TO REBUILD, AFTER ALL!

3

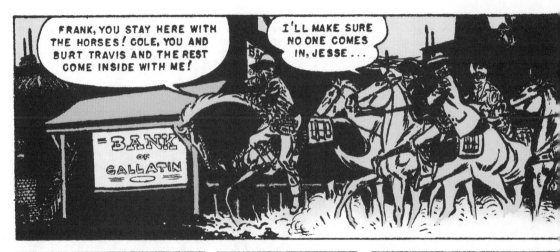

FRANK, YOU STAY HERE WITH THE HORSES! COLE, YOU AND BURT TRAVIS AND THE REST COME INSIDE WITH ME!

I'LL MAKE SURE NO ONE COMES IN, JESSE...

BANK OF GALLATIN

JESSE CAME INTO THE BANK ON THE RUN...

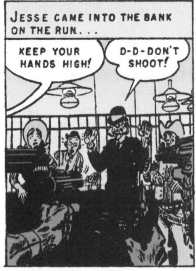

KEEP YOUR HANDS HIGH!

D-D-DON'T SHOOT!

TAKE SEVEN HUNDRED DOLLARS OUT OF THE RAILROAD'S PAYROLL AND PUT IT IN THAT SACK! AND BE QUICK ABOUT IT!

Y-Y-YESSIR!

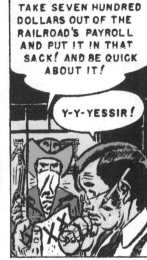

AS THE MASKED MEN WAITED, ONE OF THEM LOOKED AT A BANK OFFICIAL...

SHAW! THIS TIME I GOT YOU WHERE I WANT YOU!

I KNOW YOU—THAT VOICE! YOU'RE BURT TRAVIS!

THIS IS ONE WAY TO MAKE UP FOR THE WAY YOU AND YOUR KIND ACT!

BLAM

YOU IDIOT! I DON'T WANT GUNPLAY! NOW SEE WHAT YOU'VE DONE? YOU'VE PINNED A MURDER CHARGE ON EVERY ONE OF US!

SLAP

THE SOUNDS OF GUNPLAY BROUGHT THE ATTENTION OF THE CITIZENS OF GALLATIN TO THE BANK...

BANK ROBBERS!

SHOOT THEM DOWN LIKE THE COLD-BLOODED KILLERS THEY ARE!

BANK

4

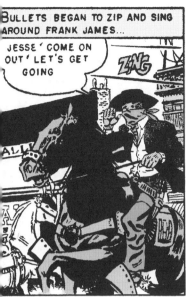

BULLETS BEGAN TO ZIP AND SING AROUND FRANK JAMES...

JESSE! COME ON OUT! LET'S GET GOING

ZING

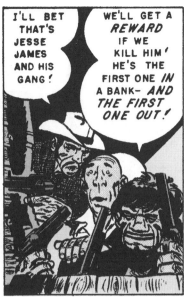

I'LL BET THAT'S JESSE JAMES AND HIS GANG!

WE'LL GET A *REWARD* IF WE KILL HIM! HE'S THE FIRST ONE *IN* A BANK— *AND THE FIRST ONE OUT!*

HERE HE COMES NOW!

WE'LL COLLECT THAT REWARD MONEY!

THREE GUNS BLASTED— AND BURT TRAVIS PLUNGED TOWARD THE GROUND

JESSE SENT ME OUT, AND..

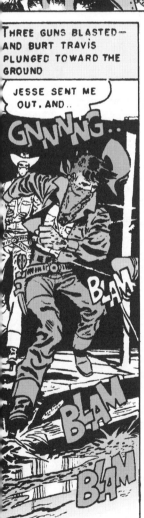

GNNNNG...

BLAM

BLAM

BLAM

THOSE GENTS THOUGHT TRAVIS WAS *ME!* I DIDN'T KNOW HE WAS COMING OUT HERE *TO HIS DEATH!*

A TRAP!

ZING

WE GOT TO *SHOOT* OUR WAY OUT!

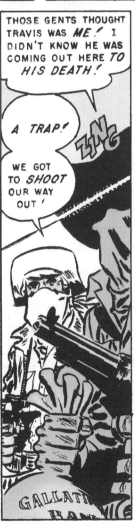

GALLATIN BANK

SICK AT HEART FOR HAVING UNWITTINGLY SENT BURT TRAVIS TO HIS DEATH, JESSE RIDES DOWN THE KILLERS...

LET'S SEE HOW GOOD YOU CAN DO AGAINST A MAN WHO *KNOWS* HE'S YOUR TARGET!

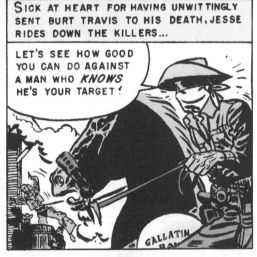

GALLATIN BANK

THIS IS FOR BURT—AND THIS—AND THIS...

BLAM

BLAM

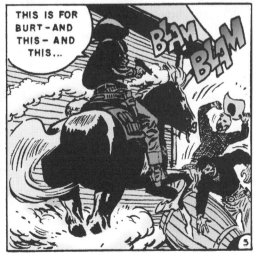

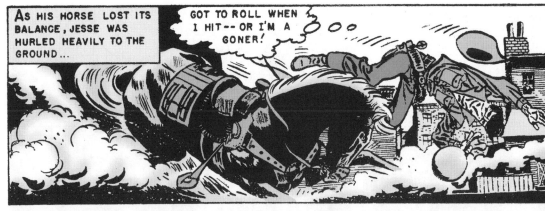

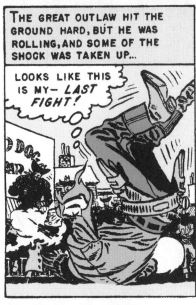

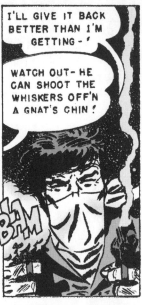

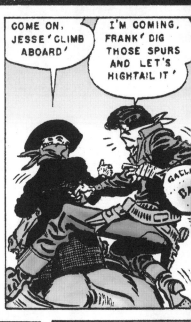

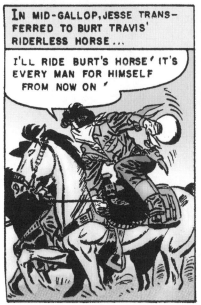

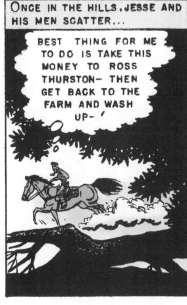

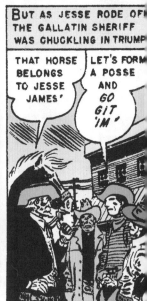

WITHIN HALF AN HOUR, A HEAVILY ARMED POSSE GALLOPED OUT OF GALLATIN.

HE CAN'T TALK HIS WAY OUT OF *THIS!* WE GOT HIM AT LAST!

IF HE PUTS UP AN ARGUMENT— SHOOT HIM DOWN!

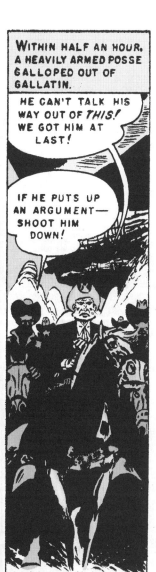

MANY MILES AWAY, JESSE REINED IN A FOAMING HORSE...

THERE'S SEVEN HUNDRED DOLLARS IN THAT SACK, ROSS! START REBUILDING YOUR HOME!

BLESS YOU, JESSE. *BLESS* YOU!

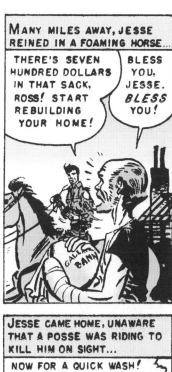

JESSE CAME HOME, UNAWARE THAT A POSSE WAS RIDING TO KILL HIM ON SIGHT...

NOW FOR A QUICK WASH! CAN'T HAVE ANYBODY SPOT THE TELLTALE STAINS AND GUNPOWDER...

SEVEN HUNDRED DOLLARS! JUST WHAT A NEW HOME WILL COST US, MOLLY! JESSE JAMES BROUGHT IT!

I'M GOING RIGHT OVER AND THANK THAT NICE JAMES BOY!

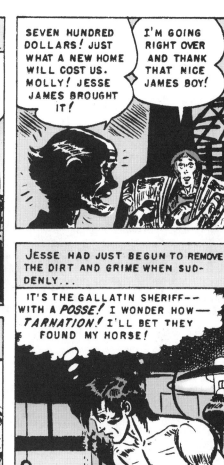

JESSE HAD JUST BEGUN TO REMOVE THE DIRT AND GRIME WHEN SUDDENLY...

IT'S THE GALLATIN SHERIFF— WITH A *POSSE!* I WONDER HOW— *TARNATION!* I'LL BET THEY FOUND MY HORSE!

SHERIFF, CLEAR OFF MY PLACE!

YOU ROBBED THE BANK AT GALLATIN AND SHOT DOWN FIVE OR MORE CITIZENS OF THE TOWN!

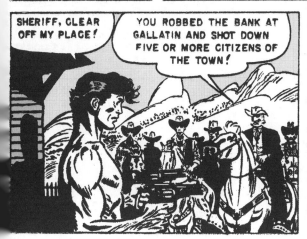

A HOT-HEADED MEMBER OF THE POSSE THREW HIS RIFLE TO HIS SHOULDER—FIRED!

LET'S STOP THIS PALAVER! I'LL SHOOT THE ROBBING DOG DOWN—AND WE'LL BE RID OF HIM!

CRACK

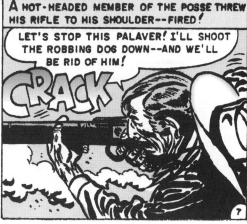

7

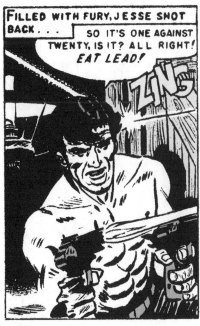

FILLED WITH FURY, JESSE SHOT BACK...

SO IT'S ONE AGAINST TWENTY, IS IT? ALL RIGHT! *EAT LEAD!*

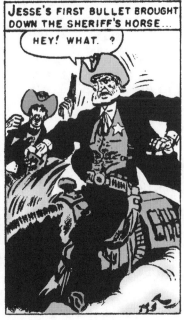

JESSE'S FIRST BULLET BROUGHT DOWN THE SHERIFF'S HORSE...

HEY! WHAT. ?

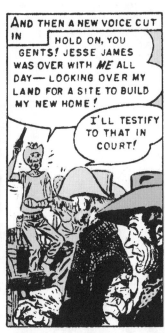

AND THEN A NEW VOICE CUT IN

HOLD ON, YOU GENTS! JESSE JAMES WAS OVER WITH *ME* ALL DAY—LOOKING OVER MY LAND FOR A SITE TO BUILD MY NEW HOME!

I'LL TESTIFY TO THAT IN COURT!

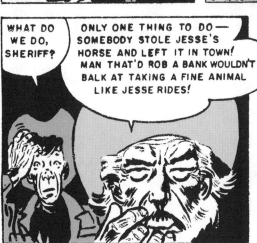

WHAT DO WE DO, SHERIFF?

ONLY ONE THING TO DO—SOMEBODY STOLE JESSE'S HORSE AND LEFT IT IN TOWN! MAN THAT'D ROB A BANK WOULDN'T BALK AT TAKING A FINE ANIMAL LIKE JESSE RIDES!

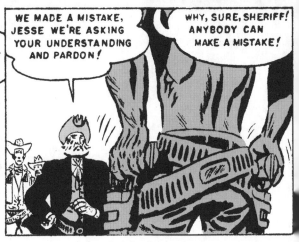

WE MADE A MISTAKE, JESSE. WE'RE ASKING YOUR UNDERSTANDING AND PARDON!

WHY, SURE, SHERIFF! ANYBODY CAN MAKE A MISTAKE!

JUST TO SHOW YOU THERE'S NO HARD FEELINGS—I WANT TO PAY FOR THAT. BRONC I SHOT OUT FROM UNDER YOU JUST NOW. I WOULDN'T WANT THAT ON MY CONSCIENCE!

THIS, THEN, WAS THAT STRANGE KING OF ALL OUT-LAWS, JESSE JAMES! TO AID A FELLOW MAN HE WOULD ROB AND KILL—YET WHEN HE SHOT TO DEFEND HIS OWN LIFE, AND KILLED A MAN'S HORSE ——HE MUST PAY FOR IT, OR BE PUNISHED BY HIS OWN CONSCIENCE.

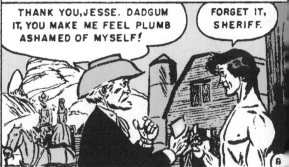

THANK YOU, JESSE. DADGUM IT, YOU MAKE ME FEEL PLUMB ASHAMED OF MYSELF!

FORGET IT, SHERIFF.

JESSE JAMES

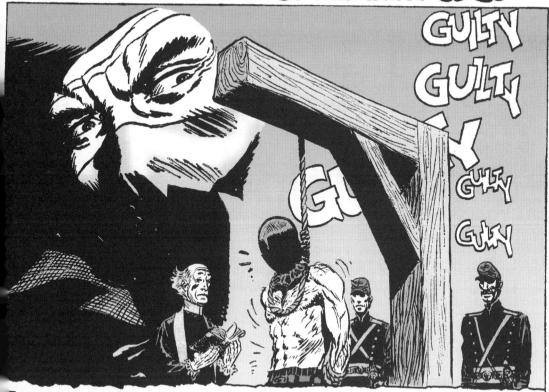

TO THE MEN WHO RODE BESIDE HIM, JESSE JAMES WAS AN IDOL. HE ENGINEERED ROBBERIES AND MANEUVERED ESCAPES. HE SPENT WITH A LAVISH HAND, AND HE NEVER LET AN INNOCENT MAN SUFFER FOR THE CRIMES HE, OR HIS WILD BUNCH, HAD COMMITTED. WHEN A RASCALLY SHERIFF, WHO USED HIS OFFICE TO COLLECT ALL THE GRAFT HE COULD, DECIDED THAT HANK MORELAND AND EDDIE DESMOND SHOULD HANG FOR THE ROBBING OF A LEADTOWN BANK—— JESSE TOOK TO THE TRAILS, IN ORDER TO BRING ABOUT——

THE GREAT PRISON BREAK!!

T WAS AN EARLY MORNING IN 1877 WHEN JESSE THUNDERED INTO LEADTOWN...

WE TIMED THIS JUST RIGHT, BOYS! THE TELLER'S UNLOCKING THE DOOR, AND THERE'S NOBODY ELSE AROUND!

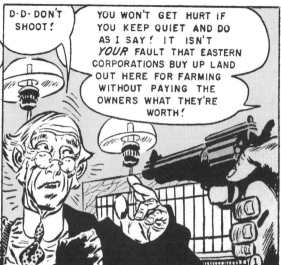

D-D-DON'T SHOOT!

YOU WON'T GET HURT IF YOU KEEP QUIET AND DO AS I SAY! IT ISN'T *YOUR* FAULT THAT EASTERN CORPORATIONS BUY UP LAND OUT HERE FOR FARMING WITHOUT PAYING THE OWNERS WHAT THEY'RE WORTH!

HONEST FARMERS LIKE HANK MORELAND AND ED DESMOND SUFFER ON ACCOUNT OF THOSE SYNDICATES. THEY SEND GANGS OF MEN AROUND TO RUIN THEIR CROPS -- THEN REFUSE TO EXTEND TIME ON THEIR MORTGAGES! ..

THE SYNDICATES BANK THEIR MONEY *HERE! THAT'S* WHY I'M TAKING IT...BECAUSE THEY OWE MORELAND AND DESMOND PLENTY! YOU UNDERSTAND?

OH, I UNDER-STAND, ALL RIGHT. YES *SIR!*

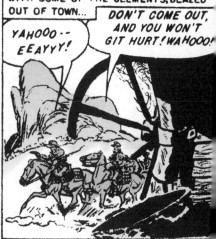

IN A THUNDERING TATTOO OF GUN-SHOTS, JESSE JAMES AND HIS BROTHER FRANK, AND THE TWO YOUNGER BOYS, WITH SOME OF THE CLEMENTS, BLAZED OUT OF TOWN...

YAHOOO-- EEAYYY!

DON'T COME OUT, AND YOU WON'T GIT HURT! WAHOOO!

SHERIFF TOLAND STARED AT THE DUST, AND A HARD, CRUEL LIGHT CAME INTO HIS EYES...

MORELAND AN' DESMOND, HE SAID...RECKON WON'T BE *TOO* LONG 'FORE I GET ME TWO ROBBERY CONVICTIONS'

HE MENTIONED THEIR NAMES -- BUT *THEY* WEREN'T *IN* ON THE JOB, SHERIFF!

SHUT *UP!* I RUN THIS TOWN THE WAY *I* SEE FIT! I TELL YUH MORELAND AN' DESMOND WERE *IN* ON THAT ROBBERY -- AND IF YUH KNOW WHAT'S GOOD FOR YUH -- *YOU'LL SAY* THEY WERE, *TOO!*

SLAP

BEFORE DAWN, A HEAVILY ARMED POSSE APPEARED BEFORE THE MORELAND AND THE DESMOND FARMHOUSES, AND THE TWO FARMERS WERE DRAGGED FROM THEIR BEDS...

WE GOT THE DIRTY BANK ROBBERS NOW! THEY'LL PAY FOR THEIR CRIMES, TOO! THEY'LL FACE TRIAL BEFORE *JUDGE PARKER!*

FOLKS DON'T CALL HIM *"THE HANGING JUDGE"* -- WITHOUT GOOD REASON!

IN THE YEAR 1875, THE GOVERNMENT HAD APPOINTED ISAAC C. PARKER AS JUDGE. HIS JURISDICTION COVERED THE ENTIRE "WILD WEST" FROM ARKANSAS TO COLORADO AND NEW MEXICO!...

GUILTY GUILTY GUILTY GUILTY GUILTY GUILT

THE GALLOWS AT FORT SMITH COULD HANG A DOZEN MEN AT ONCE. FOR TWENTY-ONE YEARS, JUDGE PARKER RULED THE WEST WITH AN IRON HAND, BECAUSE FOR TWO-THIRDS OF THAT TIME, THERE WAS *NO APPEAL ANYWHERE* FROM HIS DECISIONS!

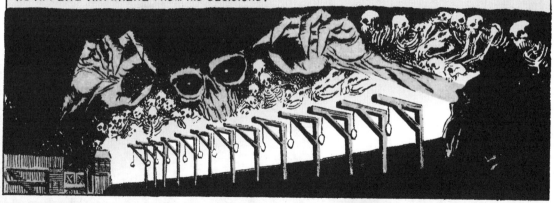

IT WAS TO THIS MAN—— CALLED "HANGING PARKER" AND "BLOODY PARKER"—— CAME SHERIFF TOLAND WITH HIS TWO PRISONERS.

SOME FOLKS CALL FORT SMITH THE "GATES OF HELL" ON ACCOUNT OF SO MANY BAD HOMBRES USE IT AS A JUMPIN' OFF PLACE. HEH! HEH!

500 MILES 'TO FORT SMITH AND HELL!

I'LL SEE IF I CAN FIX IT SO YOU BOYS GIT AN *EARLY TRIAL!*

HA HA H

HIGH IN THE MISSOURI HILLS

THEY TOOK MORELAND AND DESMOND IN— TO SWING FOR A ROBBERY WE FULLED!

WELL—WE GAVE 'EM THE MONEY WE TOOK

SURE WE DID. BUT NO MAN'S GOING TO HAVE HIS NECK STRETCHED FOR SOMETHING *I* DID! I'M HIGH-TAILING IT DOWN TO FORT SMITH. YOU HOMBRES CAN COME OR STAY! SUIT YOURSELVES!

INWARDLY, EACH MEMBER OF THE WILD BUNCH TOLD HIM-SELF, "IF THAT WAS *ME* THERE IN FORT SMITH, I'D BE DOGGONE GLAD TO HAVE JESSE JAMES RIDING TO SAVE ME FROM THE HANGMAN'S NOOSE." SO THEY RODE ALONG WITH HIM...

FORT SMITH IS RIGHT CLOSE TO THE INDIAN TERRITORY. PLENTY OF MARSHALS RIDING IN WITH PRISONERS. RECKON *WE* CUGHT TO PLAY THAT THAT GAME, *TOO!*

SOME DAYS LATER, A "COLO-RADO MARSHAL" AND HIS DEPUTY, WITH THEIR PRIS-ONERS, WALKED THEIR HORSES INTO THE BIG PARADE GROUNDS AT FORT SMITH...

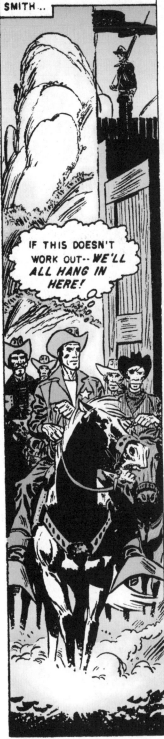

IF THIS DOESN'T WORK OUT-- *WE'LL ALL HANG IN HERE!*

CAN'T TRY MY PRISONERS FOR A WHILE, MARSHAL THERE'S MORE OF THEIR OUTLAW BUNCH COMING. THEY GOT HELD UP A WHILE BY RESERVATION-JUMPING COMANCHES!

WE'LL PUT 'EM IN JAIL AND WAIT.

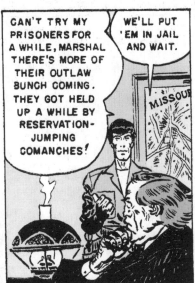

FRANK JAMES, ARCH CLEMENTS AND BOB YOUNGER WERE LOCKED IN TEMPORARY JAIL CELLS. AS JESSE WENT ALONG WITH THE JAILER, HE ACCIDENTALLY STUM-BLED...

OOOPS! PLUMB CLUMSY OF ME, BUMPING INTO YUH LIKE THAT!

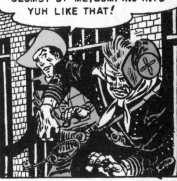

JESSE HELD A SLAB OF SOFT WAX IN HIS HAND. HE DROVE HIS HAND DOWN HARD OVER THE CELL KEY, SO ITS IMPRINT WOULD BE DRIVEN DEEP INTO THE WAX...

LATER THAT SAME DAY, COLE YOUNGER -- WHO WAS EXPERT WITH TOOLS AND THEIR REPAIR -- FORGED ANOTHER CELL DOOR KEY FROM THE WAX IMPRESSION..

I GOT THE USE OF THIS SHOP BY SAYING WE HAD TO FIX OUR GUNSIGHTS!

ALMOST DONE, NOW...

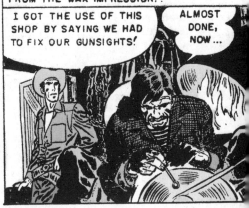

JESSE MADE HIS PLANS OVER THE GRUB-TABLE!

THEY CHANGE GUARDS HERE EVERY FIVE HOURS! MEN DON'T STAY HERE *LONG ENOUGH* TO PLAN A BREAK!

JESSE -- I THINK YOU'VE BIT OFF MORE'N YUH CAN *CHEW!*

YOU JUST LEAVE EVERY-THING TO ME, COLE! I GOT ME AN IDEA!

IMAGINE -- HERE WE SIT -- RIGHT SMACK IN FED-ERAL COURT ITSELF! GIVES ME THE *SHAKES*

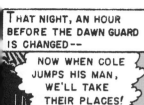

THAT NIGHT, AN HOUR BEFORE THE DAWN GUARD IS CHANGED--

NOW WHEN COLE JUMPS HIS MAN, WE'LL TAKE THEIR PLACES!

CLUMP

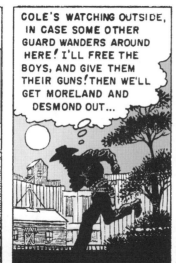

COLE'S WATCHING OUTSIDE, IN CASE SOME OTHER GUARD WANDERS AROUND HERE! I'LL FREE THE BOYS, AND GIVE THEM THEIR GUNS! THEN WE'LL GET MORELAND AND DESMOND OUT...

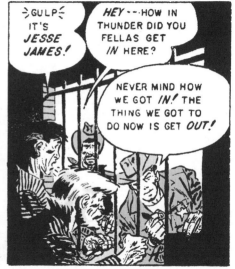

≷GULP≷ IT'S JESSE JAMES!

HEY--HOW IN THUNDER DID YOU FELLAS GET IN HERE?

NEVER MIND HOW WE GOT IN! THE THING WE GOT TO DO NOW IS GET OUT!

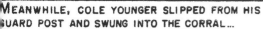

MEANWHILE, COLE YOUNGER SLIPPED FROM HIS GUARD POST AND SWUNG INTO THE CORRAL...

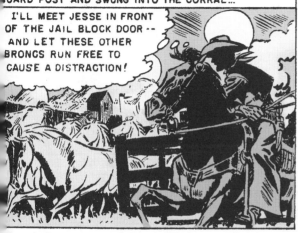

I'LL MEET JESSE IN FRONT OF THE JAIL BLOCK DOOR -- AND LET THESE OTHER BRONCS RUN FREE TO CAUSE A DISTRACTION!

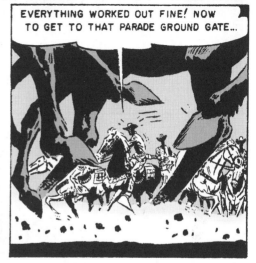

EVERYTHING WORKED OUT FINE! NOW TO GET TO THAT PARADE GROUND GATE...

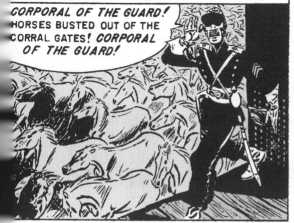

AN ALERT GUARD STARED IN AMAZEMENT AS THE HERD OF FREED PONIES THUNDERED ACROSS THE YARD. HIS CRY WOKE ECHOES AND BROUGHT MEN RUNNING...

CORPORAL OF THE GUARD! HORSES BUSTED OUT OF THE CORRAL GATES! CORPORAL OF THE GUARD!

THERE'S MEN AND HORSES ALL OVER THE YARD! JUST THE BREAK I PLANNED. LET'S GO! THEY'LL THINK WE'RE MOUNTED GUARDS COME TO ROUND UP THE STOCK...

5

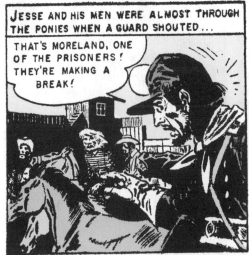

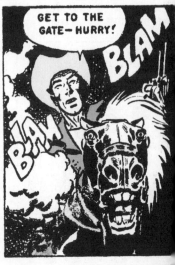

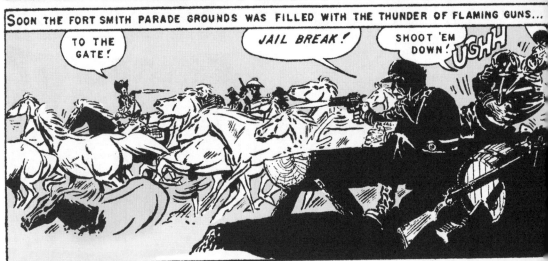

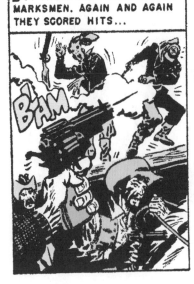

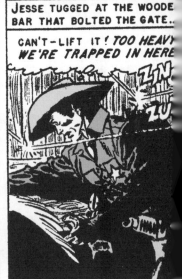

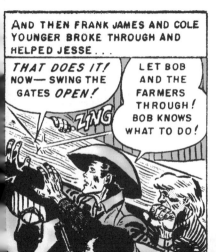

AND THEN FRANK JAMES AND COLE YOUNGER BROKE THROUGH AND HELPED JESSE...

THAT DOES IT! NOW— SWING THE GATES OPEN!

LET BOB AND THE FARMERS THROUGH! BOB KNOWS WHAT TO DO!

ZNG

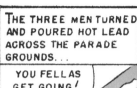

THE THREE MEN TURNED AND POURED HOT LEAD ACROSS THE PARADE GROUNDS...

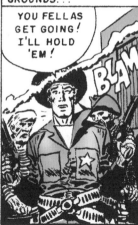

YOU FELLAS GET GOING! I'LL HOLD 'EM!

BLAM

JESSE COOLY STOPPED SHOOT-ING TO RELOAD HIS SIXGUNS. SHERIFF TOLAND LED THE WILD CHARGE TOWARD HIM...

WE'LL GIT *ONE* OF 'EM, ANYHOW! *LOOK* -- IT'S *JESSE JAMES! SHOOT HIM DOWN!*

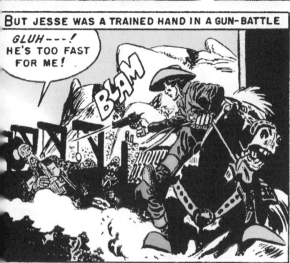

BUT JESSE WAS A TRAINED HAND IN A GUN-BATTLE

GLUH---! HE'S TOO FAST FOR ME!

BLAM

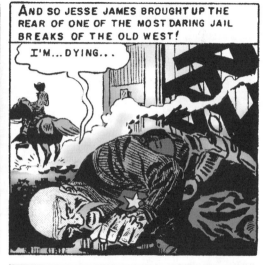

AND SO JESSE JAMES BROUGHT UP THE REAR OF ONE OF THE MOST DARING JAIL BREAKS OF THE OLD WEST!

I'M...DYING...

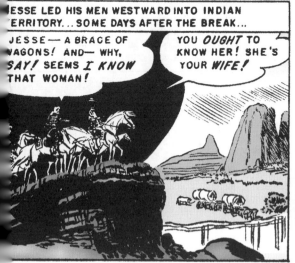

JESSE LED HIS MEN WESTWARD INTO INDIAN TERRITORY...SOME DAYS AFTER THE BREAK...

JESSE— A BRACE OF WAGONS! AND— WHY, *SAY!* SEEMS *I KNOW* THAT WOMAN!

YOU *OUGHT* TO KNOW HER! SHE'S YOUR *WIFE!*

I HAD YOUR WIVES SELL YOUR LAND AND FARMS. WITH THAT MONEY, YOU CAN BUY NEW LAND IN CALIFORNIA. THERE YOU CAN START A NEW LIFE— WITHOUT FEAR OF PENALTY FOR A CRIME YOU *DID NOT* COMMIT!

7

JESSE JAMES

"SIX-GUN SLAUGHTER at SAN ROMANO!"

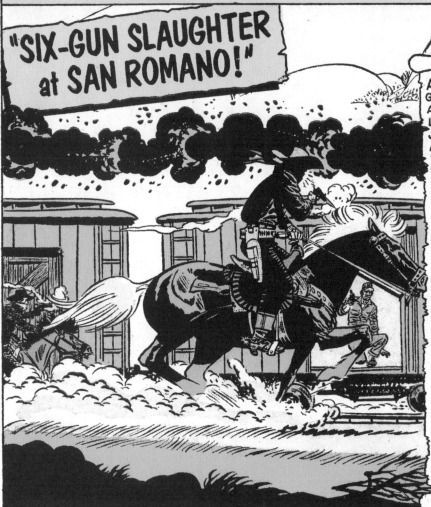

AS HIS COLT SIX-GUNS THUNDERED A BLAST OF HOT LEAD, JESSE JAMES GRASPED AT THE CHANCE TO HELP A LOVELY WOMAN--- AND TO PROFIT BY ROBBING A GREEDY MAN'S BANK... AND AS HOT BULLETS ZIPPED AND FLASHED, AS RIFLES CRACKED AND COLT REVOLVERS POURED A HAIL OF LEAD, JESSE DROVE INTO THE LITTLE BORDER TOWN TO PREVENT A WOMAN FROM COMMITTING A FATAL MISTAKE! TO DO THIS, JESSE JAMES HAD TO STEP THROUGH---- *A SIX GUN SLAUGHTER AT SAN ROMANO!*

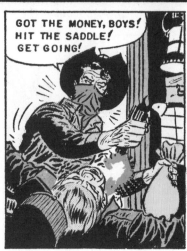

WITH ONE BOUND, JESSE JAMES WAS INTO THE BAGGAGE CAR OF THE UNION PACIFIC TRAIN. HIS GUNBARREL LIFTED AND FELL! HIS HAND GRASPED THE MONEY SACK...

GOT THE MONEY, BOYS! HIT THE SADDLE! GET GOING!

HIS COLTS BUCKED AND ROARED. DARINGLY, HE LEAPED FROM THE BAGGAGE CAR...

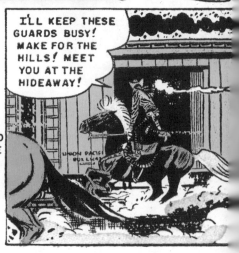

I'LL KEEP THESE GUARDS BUSY! MAKE FOR THE HILLS! MEET YOU AT THE HIDEAWAY!

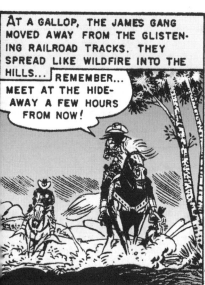

AT A GALLOP, THE JAMES GANG MOVED AWAY FROM THE GLISTENING RAILROAD TRACKS. THEY SPREAD LIKE WILDFIRE INTO THE HILLS... REMEMBER... MEET AT THE HIDE-AWAY A FEW HOURS FROM NOW!

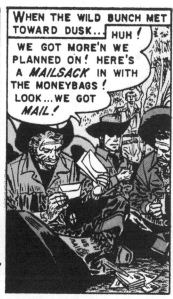

WHEN THE WILD BUNCH MET TOWARD DUSK...

HUH! WE GOT MORE'N WE PLANNED ON! HERE'S A *MAILSACK* IN WITH THE MONEYBAGS! LOOK...WE GOT *MAIL!*

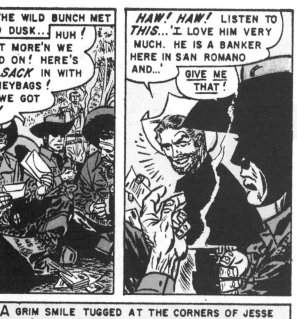

HAW! HAW! LISTEN TO *THIS*...'I LOVE HIM VERY MUCH. HE IS A BANKER HERE IN SAN ROMANO AND...'

GIVE ME THAT!

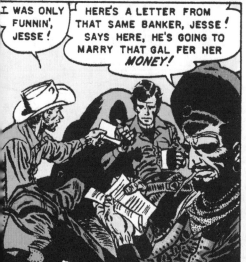

I WAS ONLY FUNNIN', JESSE!

HERE'S A LETTER FROM THAT SAME BANKER, JESSE! SAYS HERE, HE'S GOING TO MARRY THAT GAL FER HER *MONEY!*

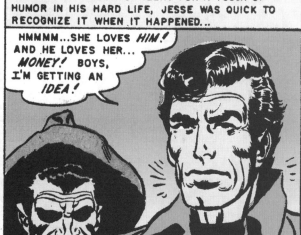

A GRIM SMILE TUGGED AT THE CORNERS OF JESSE JAMES' LIPS. ALWAYS ALERT FOR A TOUCH OF HUMOR IN HIS HARD LIFE, JESSE WAS QUICK TO RECOGNIZE IT WHEN IT HAPPENED...

HMMMM...SHE LOVES *HIM!* AND HE LOVES HER... *MONEY!* BOYS, I'M GETTING AN *IDEA!*

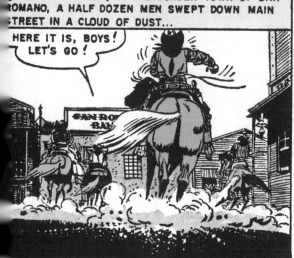

SOME DAYS LATER, IN THE BORDER TOWN OF SAN ROMANO, A HALF DOZEN MEN SWEPT DOWN MAIN STREET IN A CLOUD OF DUST...

HERE IT IS, BOYS! LET'S GO!

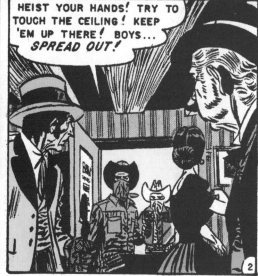

HEIST YOUR HANDS! TRY TO TOUCH THE CEILING! KEEP 'EM UP THERE! BOYS... *SPREAD OUT!*

2

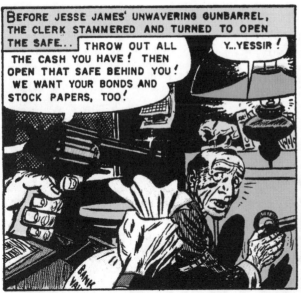

BEFORE JESSE JAMES' UNWAVERING GUNBARREL, THE CLERK STAMMERED AND TURNED TO OPEN THE SAFE...

THROW OUT ALL THE CASH YOU HAVE! THEN OPEN THAT SAFE BEHIND YOU! WE WANT YOUR BONDS AND STOCK PAPERS, TOO!

Y...YESSIR!

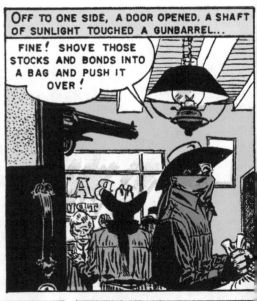

OFF TO ONE SIDE, A DOOR OPENED. A SHAFT OF SUNLIGHT TOUCHED A GUNBARREL...

FINE! SHOVE THOSE STOCKS AND BONDS INTO A BAG AND PUSH IT OVER!

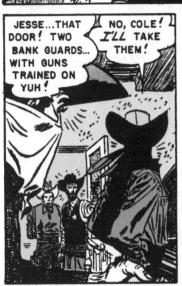

JESSE...THAT DOOR! TWO BANK GUARDS... WITH GUNS TRAINED ON YUH!

NO, COLE! I'LL TAKE THEM!

NO MAN IN ALL THE MIDDLE BORDER COUNTRY COULD USE A PAIR OF COLT SIXGUNS LIKE JESSE JAMES. THEY SEEMED A VERY PART OF HIM...

I'LL HANDLE THEM! WITH BULLETS...

GNGGGGG! GNYYAAAA!

I TAKE IT YOU ARE THE BANKER HERE?

Y...YES! I O...OWN THE BANK. BUT D...DON'T SHOOT! TAKE W...WHAT YOU HAVE AND...AND GO!

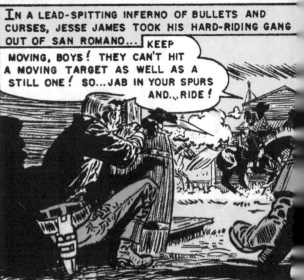

IN A LEAD-SPITTING INFERNO OF BULLETS AND CURSES, JESSE JAMES TOOK HIS HARD-RIDING GANG OUT OF SAN ROMANO...

KEEP MOVING, BOYS! THEY CAN'T HIT A MOVING TARGET AS WELL AS A STILL ONE! SO...JAB IN YOUR SPURS AND...RIDE!

MEN GRABBED RIFLES AND SIXGUNS...AND MEN DIED, FOR THOSE WHO RODE THE LONESOME TRAILS WITH JESSE JAMES SHOT WITH THE ACCURACY OF A TRICK MARKSMAN!

AAAAAGGH!

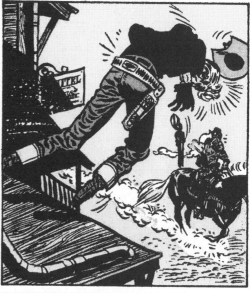

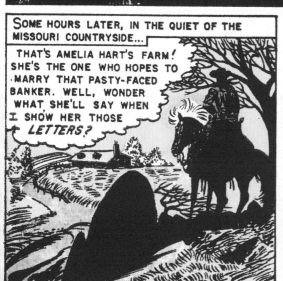

SOME HOURS LATER, IN THE QUIET OF THE MISSOURI COUNTRYSIDE...

THAT'S AMELIA HART'S FARM! SHE'S THE ONE WHO HOPES TO MARRY THAT PASTY-FACED BANKER. WELL, WONDER WHAT SHE'LL SAY WHEN I SHOW HER THOSE *LETTERS?*

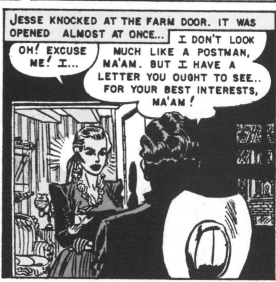

JESSE KNOCKED AT THE FARM DOOR. IT WAS OPENED ALMOST AT ONCE...

OH! EXCUSE ME! I...

I DON'T LOOK MUCH LIKE A POSTMAN, MA'AM. BUT I HAVE A LETTER YOU OUGHT TO SEE.. FOR YOUR BEST INTERESTS, MA'AM!

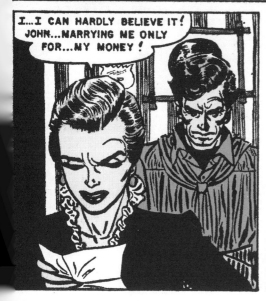

I...I CAN HARDLY BELIEVE IT! JOHN...MARRYING ME ONLY FOR...MY MONEY!

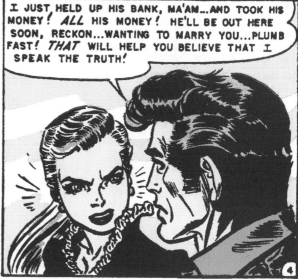

I JUST HELD UP HIS BANK, MA'AM...AND TOOK HIS MONEY! *ALL* HIS MONEY! HE'LL BE OUT HERE SOON, RECKON...WANTING TO MARRY YOU...PLUMB FAST! *THAT* WILL HELP YOU BELIEVE THAT I SPEAK THE TRUTH!

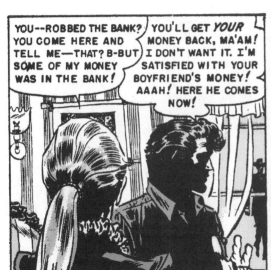

YOU--ROBBED THE BANK? YOU COME HERE AND TELL ME--THAT? B-BUT SOME OF MY MONEY WAS IN THE BANK!

YOU'LL GET *YOUR* MONEY BACK, MA'AM! I DON'T WANT IT. I'M SATISFIED WITH YOUR BOYFRIEND'S MONEY! AAAH! HERE HE COMES NOW!

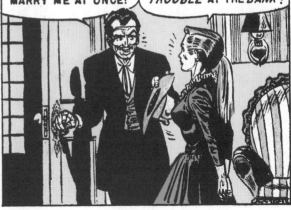

AS HE CAME IN THE FARM DOORWAY, JOHN ROMMERLEY WAS EAGER, IMPETUOUS. HE WAS SO EAGER THAT HE DID NOT SEE THE GLEAM IN AMELIA HART'S EYES...

AMELIA, DEAR! I RODE OUT TO ASK YOU TO MARRY ME AT ONCE!

JOHN--WHY SUCH A *HURRY*? ARE YOU HAVING *TROUBLE* AT THE *BANK*?

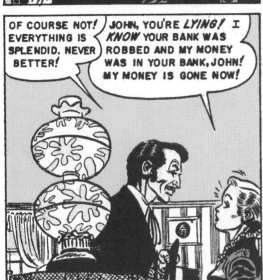

OF COURSE NOT! EVERYTHING IS SPLENDID. NEVER BETTER!

JOHN, YOU'RE *LYING*! I *KNOW* YOUR BANK WAS ROBBED AND MY MONEY WAS IN YOUR BANK, JOHN! MY MONEY IS GONE NOW!

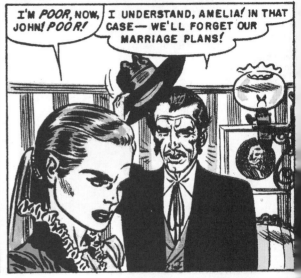

I'M *POOR*, NOW, JOHN! *POOR*!

I UNDERSTAND, AMELIA! IN THAT CASE-- WE'LL FORGET OUR MARRIAGE PLANS!

IN THE SUDDEN SILENCE OF THE FARMHOUSE LIVING ROOM AMELIA HART SOBBED DRILY. A SYMPATHETIC HAND SUDDENLY RESTED ON HER SHOULDER...

I TOLD YOU SO, MA'AM! NOW DON'T CRY! YOU'RE A LOT BETTER OFF *NOT* MARRYING SOMEBODY LIKE *HIM*!

HERE ARE YOUR STOCKS AND BONDS. I WENT OVER THEM AND TOOK THEM OUT OF THE MONEY SACKS WE TOOK FROM THE BANK. WITH THE CASH I TOSSED IN, YOU'RE A RICH WOMAN AGAIN!

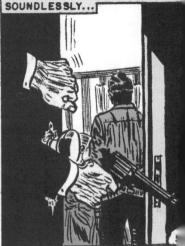

BEHIND THEM, THE DOOR SWUNG OPEN ON WELL-OILED HINGES, SOUNDLESSLY...

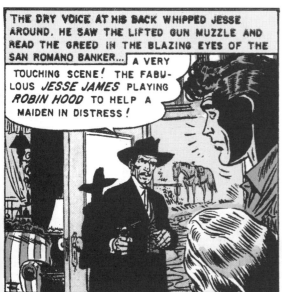

THE DRY VOICE AT HIS BACK WHIPPED JESSE AROUND. HE SAW THE LIFTED GUN MUZZLE AND READ THE GREED IN THE BLAZING EYES OF THE SAN ROMANO BANKER... A VERY TOUCHING SCENE! THE FABULOUS *JESSE JAMES* PLAYING *ROBIN HOOD* TO HELP A MAIDEN IN DISTRESS!

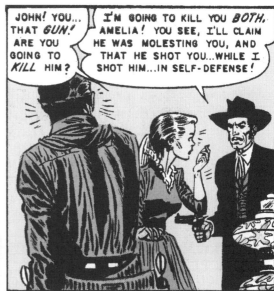

JOHN! YOU... THAT *GUN!* ARE YOU GOING TO *KILL* HIM?

I'M GOING TO KILL YOU *BOTH,* AMELIA! YOU SEE, I'LL CLAIM HE WAS MOLESTING YOU, AND THAT HE SHOT YOU...WHILE I SHOT HIM...IN SELF-DEFENSE!

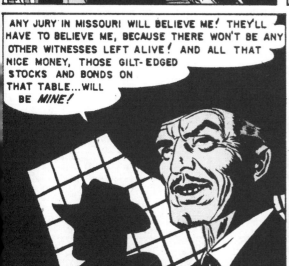

ANY JURY IN MISSOURI WILL BELIEVE ME! THEY'LL HAVE TO BELIEVE ME, BECAUSE THERE WON'T BE ANY OTHER WITNESSES LEFT ALIVE! AND ALL THAT NICE MONEY, THOSE GILT-EDGED STOCKS AND BONDS ON THAT TABLE...WILL BE *MINE!*

AS THE BANKER GLOATED OVER HIS FOOL-PROOF SCHEME, JESSE JAMES CAUTIOUSLY SLID HIS BOOT FORWARD UNTIL THE LONG SPUR HOOKED IN THE CLOTH OF THE SCATTER-RUG...

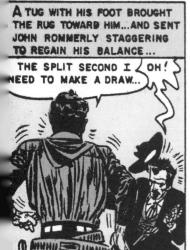

A TUG WITH HIS FOOT BROUGHT THE RUG TOWARD HIM...AND SENT JOHN ROMMERLY STAGGERING TO REGAIN HIS BALANCE...

THE SPLIT SECOND I NEED TO MAKE A DRAW...

OH!

I'M NOT KILLING YOU LIKE YOU DESERVE, ROMMERLY! I THINK A BETTER WAY TO TREAT YOU IS LET YOU FACE THE DISGRACE OF A BANK FAILURE! NOW...GET GOING WITH YOUR WORTHLESS LIFE!

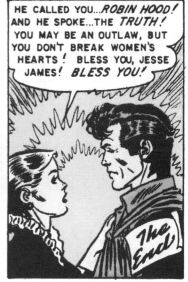

HE CALLED YOU...*ROBIN HOOD!* AND HE SPOKE...THE *TRUTH!* YOU MAY BE AN OUTLAW, BUT YOU DON'T BREAK WOMEN'S HEARTS! BLESS YOU, JESSE JAMES! *BLESS YOU!*

The End

CARMINE INFANTINO

BORN MAY 24, 1925 IN THE BOROUGH OF BROOKLYN. STUDIED AT THE SCHOOL OF INDUSTRIAL ART, ART STUDENTS LEAGUE, BROOKLYN MUSEUM OF ART AND QUEENS COLLEGE! BEGAN WORKING FOR NATIONAL COMICS SOME ELEVEN YEARS AGO... AN ASSOCIATION THAT CONTINUES TO THE PRESENT TIME!...
MY AMBITION IS TO SYNDICATE A STRIP, READ AS MUCH AS POSSIBLE IN ONE LIFETIME AND TRAVEL, TRAVEL, TRAVEL...

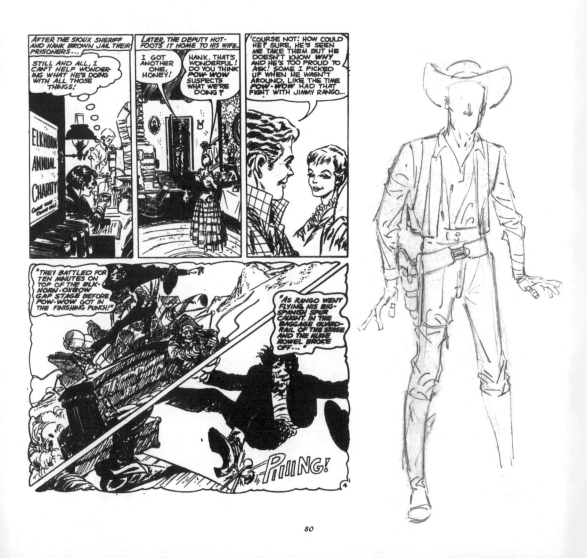

JESSE JAMES

THE RUSSELVILLE GUNFIGHTS!

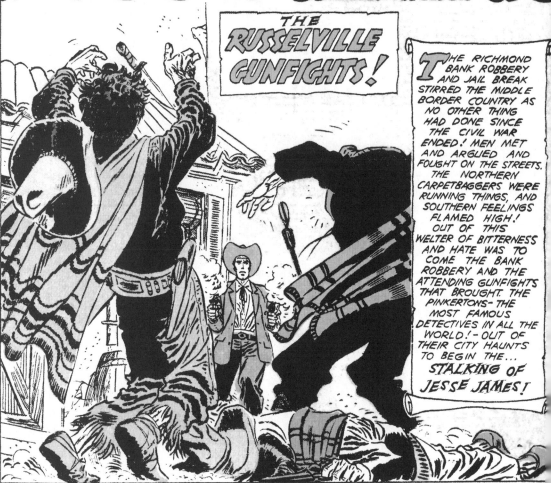

THE RICHMOND BANK ROBBERY AND JAIL BREAK STIRRED THE MIDDLE BORDER COUNTRY AS NO OTHER THING HAD DONE SINCE THE CIVIL WAR ENDED! MEN MET AND ARGUED AND FOUGHT ON THE STREETS. THE NORTHERN CARPETBAGGERS WERE RUNNING THINGS, AND SOUTHERN FEELINGS FLAMED HIGH! OUT OF THIS WELTER OF BITTERNESS AND HATE WAS TO COME THE BANK ROBBERY AND THE ATTENDING GUNFIGHTS THAT BROUGHT THE PINKERTONS—THE MOST FAMOUS DETECTIVES IN ALL THE WORLD!—OUT OF THEIR CITY HAUNTS TO BEGIN THE... STALKING OF JESSE JAMES!

I SAY THE RICHMOND ROBBERY WAS A GOOD THING!

WHY, YOU YALLER LIVERED POLECAT!

THEM TWO FELLERS THAT WAS FREED FROM THE JAIL WERE INNOCENT!

SURE THEY WERE! WHOEVER LET 'EM GO DID A GOOD DEED, BY GUM!

INTO THIS INFERNO OF HIGH FEELING CAME A YOUNG NORTHERN SOLDIER, ON FURLOUGH. AT ONCE THE HUE AND CRY WAS RAISED...

GRAB HIM!

STRING 'IM TO THE NEAREST TREE!

DANG BLUECOAT! IT'S HIS KIND AS SENDS THEM CARPETBAGGERS!

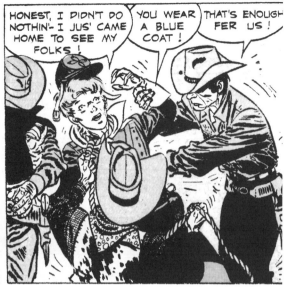

HONEST, I DIDN'T DO NOTHIN'- I JUS' CAME HOME TO SEE MY FOLKS!

YOU WEAR A BLUE COAT!

THAT'S ENOUGH FER US!

FATE AND A NEIGHBOR PAID JESSE JAMES A VISIT JUST THEN, AS HE WAS REPAIRING A BROKEN HOE...

BIG DOIN'S, JESSE! SOME O' THE BOYS CAUGHT A UNION SOLDIER OVER BY SUTTER'S FIELDS! THEY'RE FIXIN' TO STRING HIM TO A TREE...

BUT THAT-- THAT'S MURDER!

JESSE'S GUNS WERE ALWAYS NEAR HIM, ON A CONVENIENT PEG. HE RAN FOR HIS BAY STALLION AS HE STRAPPED ON HIS GUNS...

THE WAR'S OVER! WHY DON'T THOSE HOTHEADS FORGET IT? WE CAN'T CHANGE WHAT'S BEEN DONE, NOT BY HANGING AN INNOCENT BOY!

KEEP DIGGIN' DIRT, CAPTAIN! WE'VE GOT TO SAVE A BOY'S LIFE! KEEP THOSE LEGS FANNING AIR!

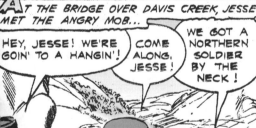

AT THE BRIDGE OVER DAVIS CREEK, JESSE MET THE ANGRY MOB...

HEY, JESSE! WE'RE GOIN' TO A HANGIN'!

COME ALONG, JESSE!

WE GOT A NORTHERN SOLDIER BY THE NECK!

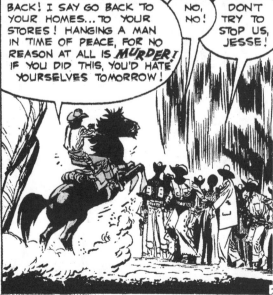

BACK! I SAY GO BACK TO YOUR HOMES...TO YOUR STORES! HANGING A MAN IN TIME OF PEACE, FOR NO REASON AT ALL IS MURDER! IF YOU DID THIS, YOU'D HATE YOURSELVES TOMORROW!

NO, NO!

DON'T TRY TO STOP US, JESSE!

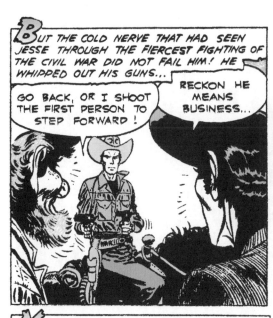

BUT THE COLD NERVE THAT HAD SEEN JESSE THROUGH THE FIERCEST FIGHTING OF THE CIVIL WAR DID NOT FAIL HIM! HE WHIPPED OUT HIS GUNS...

GO BACK, OR I SHOOT THE FIRST PERSON TO STEP FORWARD!

RECKON HE MEANS BUSINESS...

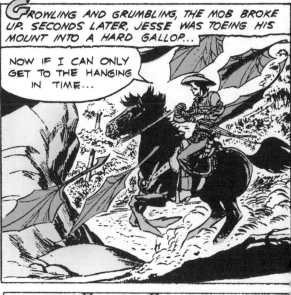

GROWLING AND GRUMBLING, THE MOB BROKE UP. SECONDS LATER, JESSE WAS TOEING HIS MOUNT INTO A HARD GALLOP...

NOW IF I CAN ONLY GET TO THE HANGING IN TIME...

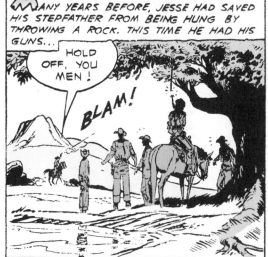

MANY YEARS BEFORE, JESSE HAD SAVED HIS STEPFATHER FROM BEING HUNG BY THROWING A ROCK. THIS TIME HE HAD HIS GUNS...

HOLD OFF, YOU MEN!

BLAM!

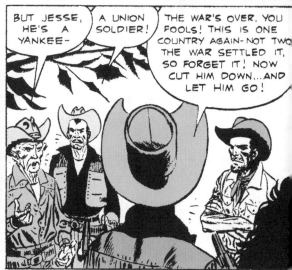

BUT JESSE, HE'S A YANKEE—

A UNION SOLDIER!

THE WAR'S OVER, YOU FOOLS! THIS IS ONE COUNTRY AGAIN—NOT TWO THE WAR SETTLED IT, SO FORGET IT! NOW CUT HIM DOWN...AND LET HIM GO!

I WON'T FORGET THIS, MISTER! I OWE YOU A LOT FOR SAVING MY LIFE. I'LL REMEMBER YOUR FACE. I'LL REPAY MY DEBT-- SOME DAY!

FORGET IT, SOLDIER. YOU'D BETTER MAKE TRACKS OUT OF HERE THESE MEN MAY CHANGE THEIR MINDS!

MEANWHILE, COLE YOUNG- ER HAD JOURNEYED DOWN INTO KENTUCKY TO LOOK OVER THE RUSSELVILLE BANK. WHEN HE RETURNED...

I TELL YOU WE CAN'T MISS. THAT BANK IS BULGING WITH MONEY!

YOU THOUGHT THE SAME ABOUT THE SAVANNAH BANK! REMEM- BER WHAT A MISTAKE THAT WAS?

I KNOW FRANK'LL GO ALONG, SO I MIGHT AS WELL RIDE WITH YOU!

GOOD BOY, JESSE! WE CAN'T MISS NOW. JESSE'S OUR GOOD LUCK CHARM...

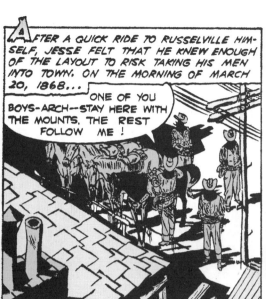

AFTER A QUICK RIDE TO RUSSELVILLE HIMSELF, JESSE FELT THAT HE KNEW ENOUGH OF THE LAYOUT TO RISK TAKING HIS MEN INTO TOWN. ON THE MORNING OF MARCH 20, 1868...

ONE OF YOU BOYS—ARCH—STAY HERE WITH THE MOUNTS. THE REST FOLLOW ME!

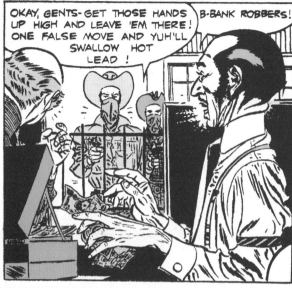

OKAY, GENTS—GET THOSE HANDS UP HIGH AND LEAVE 'EM THERE! ONE FALSE MOVE AND YUH'LL SWALLOW HOT LEAD!

B-BANK ROBBERS!

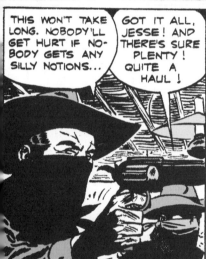

THIS WON'T TAKE LONG. NOBODY'LL GET HURT IF NOBODY GETS ANY SILLY NOTIONS...

GOT IT ALL, JESSE! AND THERE'S SURE PLENTY! QUITE A HAUL!

BUT OUTSIDE THE BANK, CURIOUS MEN WERE STARING AT THE RIDERLESS HORSES...

I GOT A HUNCH SOMETHIN' FUNNY IS GOIN' ON AT THE BANK!

SEVEN STRANGERS! JIM, I'M GOIN' TO GIT MY RIFLE!

JIM KELLY THINKS THERE'S BANK ROBBERS OVER AT THE BANK!

GRAB YOUR SHOOTIN' IRONS, BOYS!

SOMEBODY ROUSE UP THE REST OF THE TOWN!

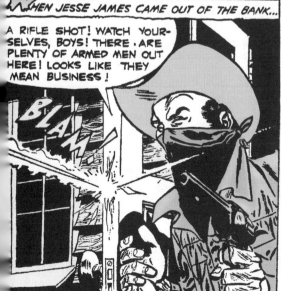

WHEN JESSE JAMES CAME OUT OF THE BANK...

A RIFLE SHOT! WATCH YOURSELVES, BOYS! THERE ARE PLENTY OF ARMED MEN OUT HERE! LOOKS LIKE THEY MEAN BUSINESS!

BLAM!

GET TO YOUR MOUNTS! KNOCK THESE GENTS FLYING! WE GOTTA BURN DAYLIGHT GETTING OUT OF HERE!

4

ONE SIDE, HOMBRE! I'M NOT FOOLING! YOU'RE NOT STOPPING US! I'LL KILL IF I HAVE TO!

GNNGG!

WITH COOLNESS AND DARING, JESSE JAMES PROVED HIS RIGHT TO LEAD HIS BANDIT BUNCH! UNFLURRIED, HE MADE SURE ALL HIS MEN WERE READY TO RIDE OUT OF RUSSELVILLE...

EVERYBODY IN THE SADDLE? THEN LET'S RIDE!

I'LL TAKE THESE MEN OUT OF THE PLAY! USE YOUR SPURS, BOYS! GET MOVING!

YIJI!

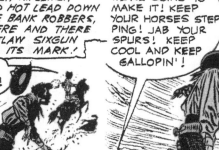

HIDDEN RIFLEMEN POURED HOT LEAD DOWN ON THE BANK ROBBERS, BUT HERE AND THERE AN OUTLAW SIXGUN FOUND ITS MARK!

GOT HIM!

WE'RE GOING TO MAKE IT! KEEP YOUR HORSES STEPPING! JAB YOUR SPURS! KEEP COOL AND KEEP GALLOPIN'!

THEY'RE MOVIN' TOO FAST TO GE A GOOD BEAD ON 'E

ONCE AGAIN THE BANDIT BUNCH SPLIT UP, TO RIDE THE LONELY TRAILS BACK TO MISSOURI, ONE BY ONE. SOME DAYS LATER, IN THEIR HILL-COUNTRY HIDEOUT...

OVER FOURTEEN THOUSAND DOLLARS, JESSE! IT'S THE BEST HAUL WE EVER MADE!

MAYBE THE LAST, TOO-- I HEARD THE BANKS AROUND HERE ARE CALLING IN THE PINKERTONS!

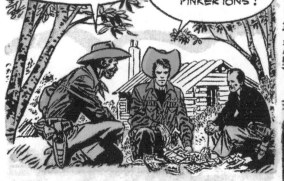

AROUSED BY THE ROBBERIES THAT TOOK THOUSANDS OF DOLLARS FROM THEM, THE BAN OF THE MIDDLE BORDER FINALLY ACTED. TH HIRED ALLAN PINKERTON...AT THAT TIME THE WORLD'S FOREMOST DETECTIVE!

FIND THE BANK ROBBERS, PINKERTON-- AND NAME YOUR OWN PRICE!

I'VE NEVE FAILED YET, SIF AND I WON'T FAIL NOW!

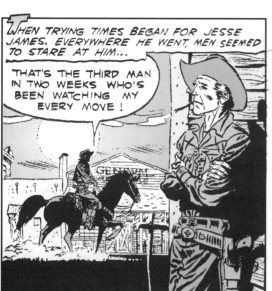

WHEN TRYING TIMES BEGAN FOR JESSE JAMES. EVERYWHERE HE WENT, MEN SEEMED TO STARE AT HIM...

THAT'S THE THIRD MAN IN TWO WEEKS WHO'S BEEN WATCHING MY EVERY MOVE!

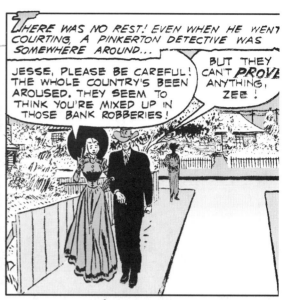

THERE WAS NO REST! EVEN WHEN HE WENT COURTING, A PINKERTON DETECTIVE WAS SOMEWHERE AROUND...

JESSE, PLEASE BE CAREFUL! THE WHOLE COUNTRY'S BEEN AROUSED. THEY SEEM TO THINK YOU'RE MIXED UP IN THOSE BANK ROBBERIES!

BUT THEY CAN'T *PROVE* ANYTHING, ZEE!

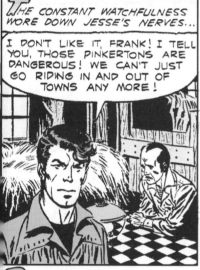

THE CONSTANT WATCHFULNESS WORE DOWN JESSE'S NERVES...

I DON'T LIKE IT, FRANK! I TELL YOU, THOSE PINKERTONS ARE DANGEROUS! WE CAN'T JUST GO RIDING IN AND OUT OF TOWNS ANY MORE!

JESSE HAD NEVER INTENDED TO LEAD A LIFE OF CRIME! NOW HE DECIDED IT WAS A GOOD TIME TO LEAVE MISSOURI!

I'M TAKING MY CUT OF THE BANK LOOT RIGHT NOW. I'M GOING ON A TRIP. I'LL HIT NEW YORK, THEN GO BY BOAT TO CALIFORNIA, UNTIL THINGS BLOW OVER.

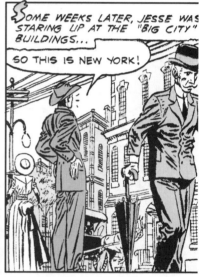

SOME WEEKS LATER, JESSE WAS STARING UP AT THE "BIG CITY" BUILDINGS...

SO THIS IS NEW YORK!

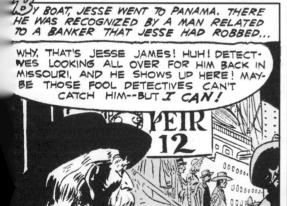

BY BOAT, JESSE WENT TO PANAMA. THERE HE WAS RECOGNIZED BY A MAN RELATED TO A BANKER THAT JESSE HAD ROBBED...

WHY, THAT'S JESSE JAMES! HUH! DETECTIVES LOOKING ALL OVER FOR HIM BACK IN MISSOURI, AND HE SHOWS UP HERE! MAYBE THOSE FOOL DETECTIVES CAN'T CATCH HIM--BUT *I CAN!*

PEIR 12

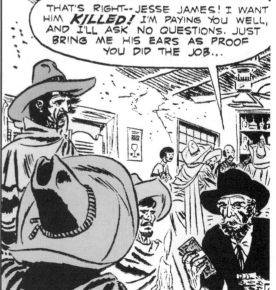

THAT'S RIGHT--JESSE JAMES! I WANT HIM *KILLED!* I'M PAYING YOU WELL, AND I'LL ASK NO QUESTIONS. JUST BRING ME HIS EARS AS PROOF YOU DID THE JOB...

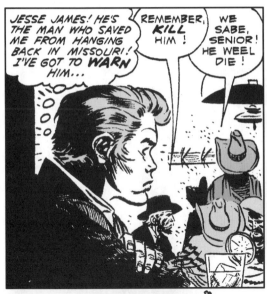

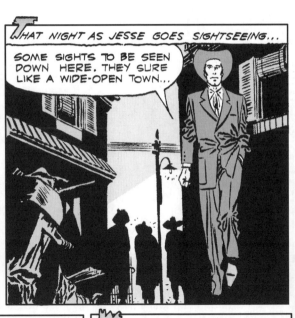

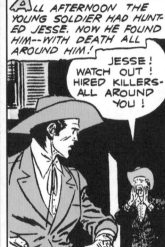

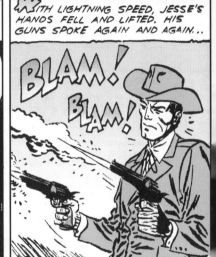

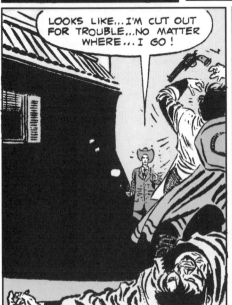

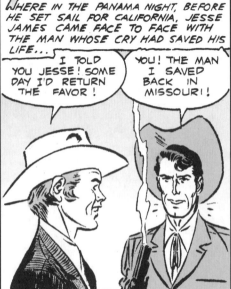

JESSE JAMES

"The APACHE KID TREASURE!"

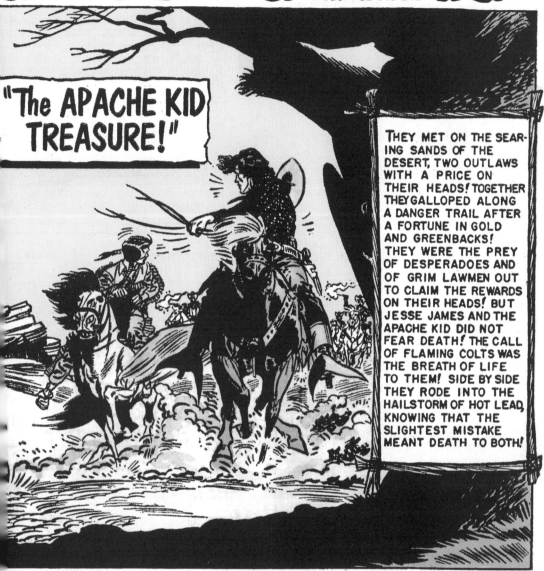

THEY MET ON THE SEARING SANDS OF THE DESERT, TWO OUTLAWS WITH A PRICE ON THEIR HEADS! TOGETHER THEY GALLOPED ALONG A DANGER TRAIL AFTER A FORTUNE IN GOLD AND GREENBACKS! THEY WERE THE PREY OF DESPERADOES AND OF GRIM LAWMEN OUT TO CLAIM THE REWARDS ON THEIR HEADS! BUT JESSE JAMES AND THE APACHE KID DID NOT FEAR DEATH! THE CALL OF FLAMING COLTS WAS THE BREATH OF LIFE TO THEM! SIDE BY SIDE THEY RODE INTO THE HAILSTORM OF HOT LEAD, KNOWING THAT THE SLIGHTEST MISTAKE MEANT DEATH TO BOTH!

...TURED ...HIRST, ...ODY ...RED BY ...ULLETS ...E IT, ...APACHE ...TAG- ...D ...OSS

...DED ...EPIPE ...RT...

ROBBED ME...TOOK THE MONEY I HELPED THEM TO GET...THEN SHOT ME! BUT I'LL GET MY REVENGE...

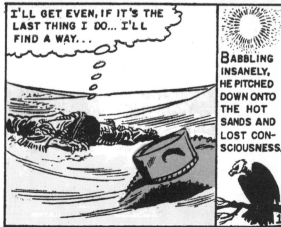

I'LL GET EVEN, IF IT'S THE LAST THING I DO... I'LL FIND A WAY...

BABBLING INSANELY, HE PITCHED DOWN ONTO THE HOT SANDS AND LOST CONSCIOUSNESS.

MOVING SLOWLY ACROSS THE DESERT CAME JESSE JAMES. BACK HOME IN MISSOURI, THE PINKERTON DETECTIVES WERE MAKING THINGS HOT FOR HIM, SO JESSE DECIDED TO TAKE A LITTLE VACATION. AND AS FATE SO OFTEN DIRECTS MEN'S FOOTSTEPS, THEY DIRECTED JESSE'S TOWARD A MAN WHO LAY DYING...

A MAN! HUH... LOOKS LIKE HE'S BEEN PUMPED FULL OF LEAD!

SOON, AS FRESH WATER POURED DOWN HIS THROAT, THE APACHE KID OPENED HIS EYES...

YOU'RE NO INDIAN, THOUGH YOU'VE INDIAN BLOOD! HERE, OLD TIMER... FRESH WATER!

TH...THANKS! RECKON YOU SAVED MY LIFE!

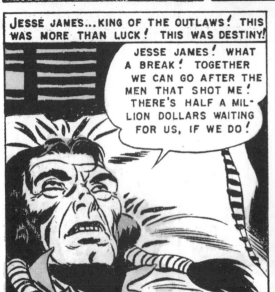

SOME HOURS LATER, ON THE RIM OF THE DESERT, A GHOST TOWN LOOMS ABOVE THE FLAT PRAIRIE LAND...

WE'LL FIND A BED IN THIS PLACE. IT'LL BE A LOT BETTER THAN THE COLD GROUND!

AIN'T SLEPT IN A BED FOR THREE MONTHS!

I'M NOT A MAN TO FOR- GET THIS! WHAT'S YOUR HANDLE?

I'M JESSE JAMES!

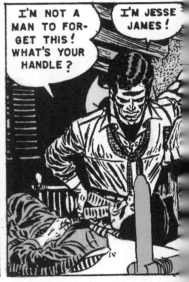

JESSE JAMES...KING OF THE OUTLAWS! THIS WAS MORE THAN LUCK! THIS WAS DESTINY!

JESSE JAMES! WHAT A BREAK! TOGETHER WE CAN GO AFTER THE MEN THAT SHOT ME! THERE'S HALF A MIL- LION DOLLARS WAITING FOR US, IF WE DO!

A HALF MILLION?

IT'S THE TAKE FROM A UNION PACIFIC TRAIN ME AND MY GANG HELD UP ABOUT A WEEK AGO!

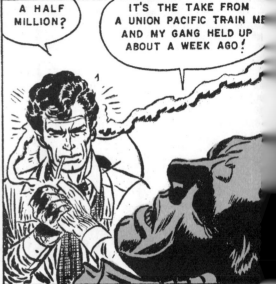

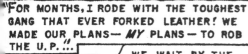

"FOR MONTHS, I RODE WITH THE TOUGHEST GANG THAT EVER FORKED LEATHER! WE MADE OUR PLANS—*MY* PLANS—TO ROB THE U.P...."

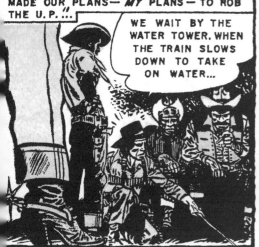

WE WAIT BY THE WATER TOWER. WHEN THE TRAIN SLOWS DOWN TO TAKE ON WATER...

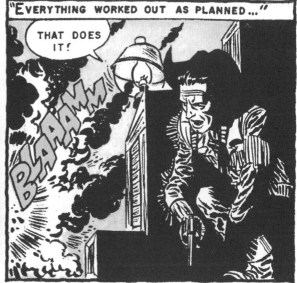

"EVERYTHING WORKED OUT AS PLANNED..."

THAT DOES IT!

BLAAMM

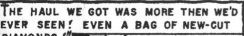

THE HAUL WE GOT WAS MORE THEN WE'D EVER SEEN! EVEN A BAG OF NEW-CUT DIAMONDS!"

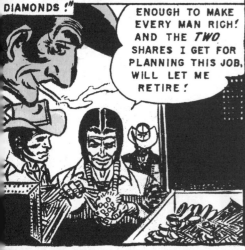

ENOUGH TO MAKE EVERY MAN RICH! AND THE *TWO* SHARES I GET FOR PLANNING THIS JOB, WILL LET ME RETIRE!

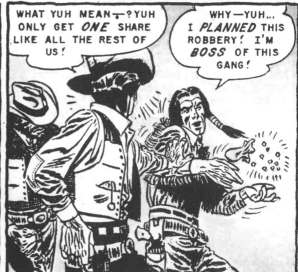

WHAT YUH MEAN—? YUH ONLY GET *ONE* SHARE LIKE ALL THE REST OF US!

WHY—YUH... I *PLANNED* THIS ROBBERY! I'M *BOSS* OF THIS GANG!

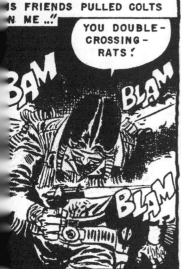

BEAT HIM TO THE DRAW, BUT [H]IS FRIENDS PULLED COLTS [O]N ME..."

YOU DOUBLE-CROSSING-RATS!

BAM

BLAM

BLAM

"THEY LEFT ME THERE ON THE DESERT. BUT I DIDN'T DIE! I STAGGERED ACROSS THOSE SANDS—UNTIL YOU FOUND ME!"

GET THEM... IF IT'S THE LAST THING I... EVER... DO...!

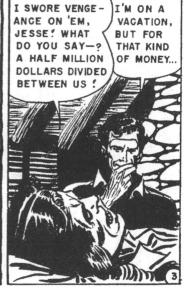

I SWORE VENGEANCE ON 'EM, JESSE! WHAT DO YOU SAY—? A HALF MILLION DOLLARS DIVIDED BETWEEN US!

I'M ON A VACATION, BUT FOR THAT KIND OF MONEY...

3

FANATICALLY THE APACHE KID FOUGHT BACK TO HEALTH...

IT WON'T BE LONG 'FORE I'M FIT TO RIDE! THOSE RATS ARE HOLED UP IN THE CORDILLERAS. I KNOW THEIR HIDEOUT. WHAT A *SURPRISE* THEY'RE GOIN' TO GET!

AND THEN ONE DAY JESSE JAMES AND THE APACHE KID GALLOPED OUT OF TOWN...

THANKS FOR RIDING OUT AN' BUYIN' ME NEW GUNS AND A BRONG, JESSE!

I'LL BE WELL REPAID-- WHEN WE GET THAT HALF MILLION!

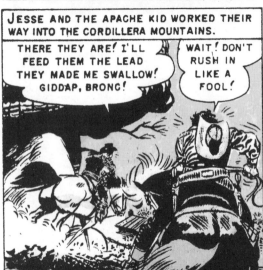

JESSE AND THE APACHE KID WORKED THEIR WAY INTO THE CORDILLERA MOUNTAINS.

THERE THEY ARE! I'LL FEED THEM THE LEAD THEY MADE ME SWALLOW! GIDDAP, BRONC!

WAIT! DON'T RUSH IN LIKE A FOOL!

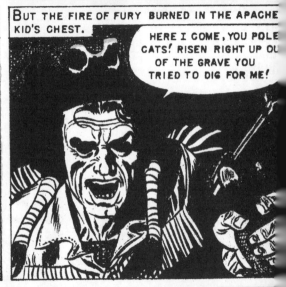

BUT THE FIRE OF FURY BURNED IN THE APACHE KID'S CHEST.

HERE I COME, YOU POLE CATS! RISEN RIGHT UP OUT OF THE GRAVE YOU TRIED TO DIG FOR ME!

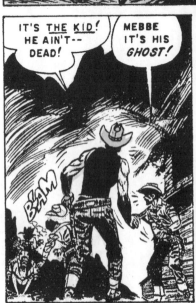

IT'S *THE KID!* HE AIN'T-- DEAD!

MEBBE IT'S HIS *GHOST!*

BLAM

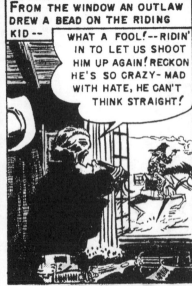

FROM THE WINDOW AN OUTLAW DREW A BEAD ON THE RIDING KID--

WHAT A FOOL!--RIDIN' IN TO LET US SHOOT HIM UP AGAIN! RECKON HE'S SO CRAZY-MAD WITH HATE, HE CAN'T THINK STRAIGHT!

NO ONE SAW JESSE JAMES AS HE RODE IN TO COVER HIS PARTNER...

BLAM

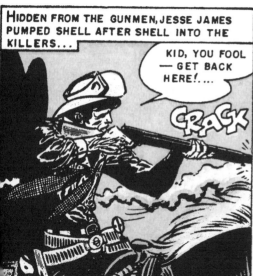

HIDDEN FROM THE GUNMEN, JESSE JAMES PUMPED SHELL AFTER SHELL INTO THE KILLERS...

KID, YOU FOOL — GET BACK HERE!....

CRACK

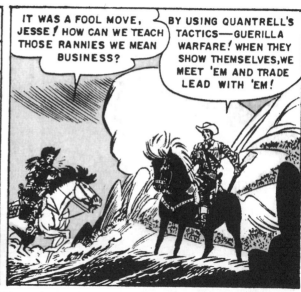

IT WAS A FOOL MOVE, JESSE! HOW CAN WE TEACH THOSE RANNIES WE MEAN BUSINESS?

BY USING QUANTRELL'S TACTICS—GUERILLA WARFARE! WHEN THEY SHOW THEMSELVES, WE MEET 'EM AND TRADE LEAD WITH 'EM!

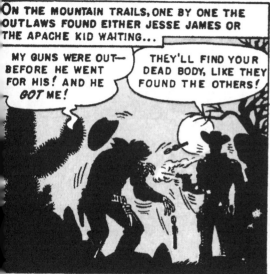

ON THE MOUNTAIN TRAILS, ONE BY ONE THE OUTLAWS FOUND EITHER JESSE JAMES OR THE APACHE KID WAITING...

MY GUNS WERE OUT— BEFORE HE WENT FOR HIS! AND HE GOT ME!

THEY'LL FIND YOUR DEAD BODY, LIKE THEY FOUND THE OTHERS!

THIS IDEA OF JESSE'S IS WORKING OUT PLUMB FINE! SOON THERE WON'T BE NO MORE RATS TO KILL.

TERRIFIED BY THESE SILENT KILLERS, THE REMAINING OUTLAWS HUDDLE IN THEIR HIDEOUT...

THEY'LL KILL US ALL!

WE AIN'T GOT A CHANCE AGAINST SUCH GUNMEN!

MEBBE WE AIN'T—BUT THERE'S SHERIFFS AND RANGERS THAT'D GIVE THEIR EYE TEETH TO KNOW WHERE JESSE JAMES AND THE APACHE KID CAN BE FOUND!

HUH?

I'M GOING TO SEND A TELEGRAM! THEY WON'T SEE ME IN THE DARK! TOMORROW—THE LAW WILL HAVE ITS HANDS ON THEM TWO GALOOTS—AND WE'LL HAVE NOTHIN' TO WORRY ABOUT!

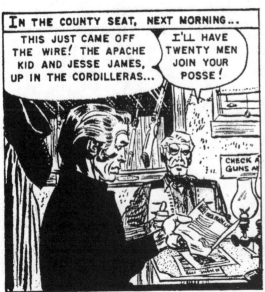

IN THE COUNTY SEAT, NEXT MORNING...

THIS JUST CAME OFF THE WIRE! THE APACHE KID AND JESSE JAMES, UP IN THE CORDILLERAS...

I'LL HAVE TWENTY MEN JOIN YOUR POSSE!

CHECK A GUNS A

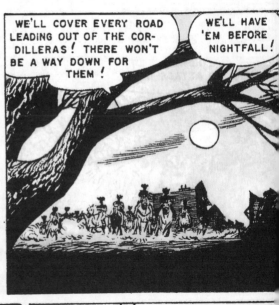

WE'LL COVER EVERY ROAD LEADING OUT OF THE COR- DILLERAS! THERE WON'T BE A WAY DOWN FOR THEM!

WE'LL HAVE 'EM BEFORE NIGHTFALL!

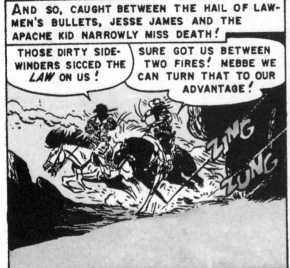

AND SO, CAUGHT BETWEEN THE HAIL OF LAW- MEN'S BULLETS, JESSE JAMES AND THE APACHE KID NARROWLY MISS DEATH!

THOSE DIRTY SIDE- WINDERS SICCED THE LAW ON US!

SURE GOT US BETWEEN TWO FIRES! MEBBE WE CAN TURN THAT TO OUR ADVANTAGE!

ZING ZUNG

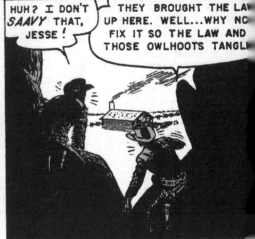

HUH? I DON'T SAAVY THAT, JESSE!

THEY BROUGHT THE LAW UP HERE. WELL...WHY NO FIX IT SO THE LAW AND THOSE OWLHOOTS TANGLE

ALL THAT DAY THEY FLED THE POSSE THE RANGERS. TOWARD DUSK...

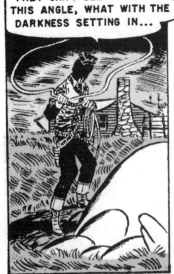

THEY CAN'T SEE ME FROM THIS ANGLE, WHAT WITH THE DARKNESS SETTING IN...

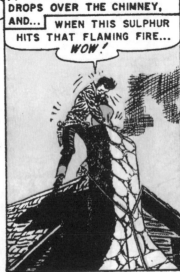

A CAREFULLY THROWN LOOP DROPS OVER THE CHIMNEY, AND...

WHEN THIS SULPHUR HITS THAT FLAMING FIRE... WOW!

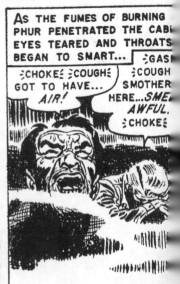

AS THE FUMES OF BURNING PHUR PENETRATED THE CABI EYES TEARED AND THROATS BEGAN TO SMART...

≥CHOKE≤ ≥COUGH≤ GOT TO HAVE... AIR!

≥GAS

≥COUGH SMOTHER HERE...SME AWFUL. ≥CHOKE≤

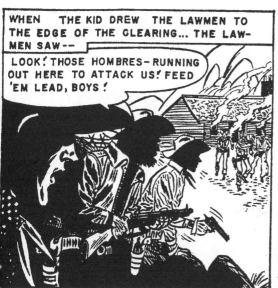

WHEN THE KID DREW THE LAWMEN TO THE EDGE OF THE CLEARING... THE LAWMEN SAW--

LOOK! THOSE HOMBRES--RUNNING OUT HERE TO ATTACK US! FEED 'EM LEAD, BOYS!

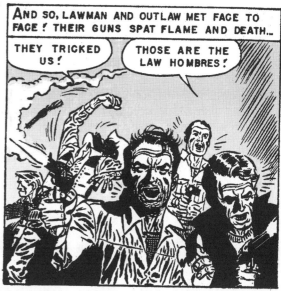

AND SO, LAWMAN AND OUTLAW MET FACE TO FACE! THEIR GUNS SPAT FLAME AND DEATH...

THEY TRICKED US!

THOSE ARE THE LAW HOMBRES!

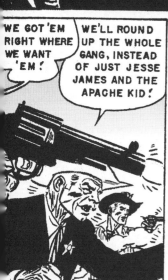

WE GOT 'EM RIGHT WHERE WE WANT 'EM!

WE'LL ROUND UP THE WHOLE GANG, INSTEAD OF JUST JESSE JAMES AND THE APACHE KID!

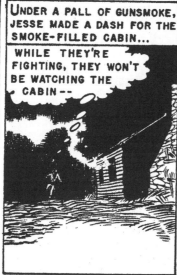

UNDER A PALL OF GUNSMOKE, JESSE MADE A DASH FOR THE SMOKE-FILLED CABIN...

WHILE THEY'RE FIGHTING, THEY WON'T BE WATCHING THE CABIN--

THIS WET NECKERCHIEF WILL KEEP THOSE FUMES OUT OF MY NOSE LONG ENOUGH FOR ME TO FIND THAT LOOT-I HOPE!

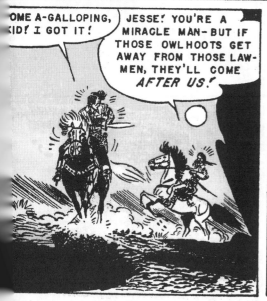

OME A-GALLOPING, KID! I GOT IT!

JESSE! YOU'RE A MIRACLE MAN-BUT IF THOSE OWLHOOTS GET AWAY FROM THOSE LAWMEN, THEY'LL COME AFTER US!

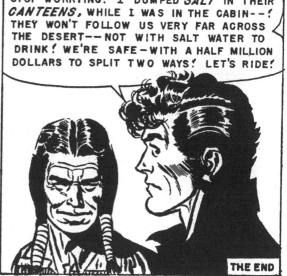

STOP WORRYING! I DUMPED SALT IN THEIR CANTEENS, WHILE I WAS IN THE CABIN--! THEY WON'T FOLLOW US VERY FAR ACROSS THE DESERT--NOT WITH SALT WATER TO DRINK! WE'RE SAFE-WITH A HALF MILLION DOLLARS TO SPLIT TWO WAYS! LET'S RIDE!

THE END

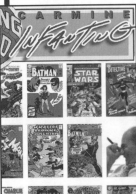

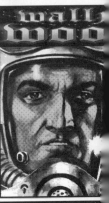